art beyond isms

MASTERWORKS FROM EL GRECO TO PICASSO
IN THE PHILLIPS COLLECTION

art beyond isms

MASTERWORKS FROM EL GRECO TO PICASSO
IN THE PHILLIPS COLLECTION

Eliza E. Rathbone
with Johanna Halford-MacLeod

THE PHILLIPS
COLLECTION

III THIRD MILLENNIUM
PUBLISHING, LONDON

Copyright © 2002 The Phillips Collection, Washington, D.C.

"Seeing Beautifully: A Vision of the Whole"
Copyright © 2002 by Eliza E. Rathbone

"Paintings and Sculpture" © 2002 by Johanna Halford-MacLeod

First published in 2002 by Third Millennium Publishing Limited,
a subsidiary of Third Millennium Information Limited,
Farringdon House, 105–107 Farringdon Road
London EC1R 3BU, United Kingdom

in association with The Phillips Collection,
1600 Twenty-first Street, NW
Washington, D.C 20009-1090
www.phillipscollection.org

Reprinted January 2004
Reprinted April 2004

Published on the occasion of the exhibition, *Art beyond isms: Masterworks from El Greco to Picasso in The Phillips Collection*, organized by The Phillips Collection, Washington, D.C.

September 22, 2002–January 5, 2003
Museum of Fine Arts, Houston, TX

January 23–May 4, 2003
Phoenix Art Museum, Phoenix, AZ

May 23–September 1, 2003
Albright-Knox Art Gallery, Buffalo, NY

October 4, 2003–January 4, 2004
Denver Art Museum, Denver, CO

February 6–May 16, 2004
Frist Center for the Visual Arts, Nashville, TN

May 27–September 27, 2004
Fondation Pierre Gianadda, Martigny, Switzerland

October 17, 2004–January 2, 2005
Los Angeles County Museum of Art, Los Angeles, CA

February 20–May 29, 2005
The Cleveland Museum of Art, Cleveland, OH

ISBN 1 903942 08 X

All measurements are in inches and centimeters;
Height precedes width precedes depth.
Edited by Donald Garfield and Lisa Siegrist
Copy-editing by Honeychurch Associates, Cambridge, UK
Designed by Pardoe Blacker Limited, a subsidiary of Third Millennium Information Limited
Produced by Third Millennium Publishing, a subsidiary of Third Millennium Information Limited
Printed and bound in Singapore
Photographs: The Philips Collection, Washington D.C.

Library of Congress Cataloging-in-Publication Data

Phillips Collection
Art beyond Isms: masterworks from El Greco to Picasso in the Phillips collection/Eliza E. Rathbone with Johanna Halford-MacLeod.
p. cm.
Published on the occasion of an exhibition organized by the Phillips Collection, Washington, D.C. and held at the Museum of Fine Arts, Houston and four other institutions between Sept 22, 2002 and winter 2004.
Includes index.

1. Painting, European–Exhibitions. 2. Painting–Washington (D.C.)–Exhibitions. 3. Phillips Collection–Exhibitions. I. Rathbone, Eliza E., 1948–II. Halford MacLeod,
Johanna. III. Museum of Fine Arts, Houston. IV. Title.

ND454.P442002
709'.4'074753–dc21

2002022087

Front cover: Vincent van Gogh (Dutch, 1853–1890), *Entrance to the Public Garden in Arles*, 1888 (detail)
Back cover: Paul Klee (Swiss, 1879–1940), *Cathedral*, 1924
Contents: Alberto Giacometti (Swiss, 1901–1966), *Monumental Head*, 1960
Page 8: Pablo Picasso (Spanish, 1881–1973), *The Blue Room*, 1901 (detail)
Page 26: Odilon Redon (French, 1840–1916), *Mystery*, ca. 1910 (detail)

Contents

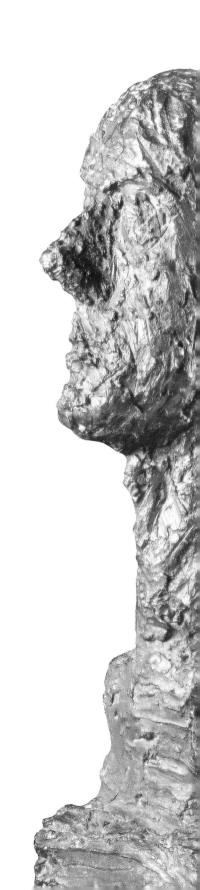

In the lore of The Phillips Collection, 1923 is remembered as a very good year. Having opened their new museum two years before, Duncan and Marjorie Phillips were seeking to make a very major acquisition, the sort of picture that would put their gallery on the map, and create a destination for visitors to Washington, long before Washington had become home to so many important museums. This would have to be the kind of picture that would make the front page of both the *Washington Post* and the *New York Times*. And as everyone now knows, they succeeded beyond their wildest dreams when they brought home from Paris Renoir's celebrated and ravishing painting, the *Luncheon of the Boating Party*, which has remained the signature image of The Phillips Collection for eighty years.

Nineteen twenty-three was also the tenth anniversary of Duncan Phillips's famous review of the even more famous Armory Show in New York which introduced the American public to the major figures of the European and American avant-garde. A formative and controversial event, the Armory Show scandalized many, including the young Duncan Phillips whose withering review, published in the *International Studio*, dismissed the event as "stupefying in its vulgarity." Hence, Phillips began to create an inventory of stories he would delight in telling on himself in the years to come—for in the same article he singled out individual artists including van Gogh, Gauguin, Cézanne, and Matisse for all sorts of choice epithets. These are, of course, the towering art historical figures whose work he collected with such consummate skill. They form the core of what most people probably visualize when they think about The Phillips Collection.

The quality of the collection and the importance of individual works are all the more important when one remembers that Phillips began the formation of what he called a "museum of modern art and its sources" in 1918, before there was a Museum of Modern Art in New York, before there was a National Gallery of Art on the Mall, before the histories of modern art had been written, and before the art history departments had been created at American universities.

But when Duncan Phillips opened up his home at the corner of Twenty-first and Q Streets in the nation's capital, it wasn't simply to share with the public the great trophies that he had accumulated. It was rather to provide a forum where the visitor could linger and, in time, come to discern the different visual languages which modern artists were free to create and refine. He wanted his visitors to arrive at the point where they could "see beautifully, as true artists see," and in the process come away with the kinds of experiences that Phillips described over the course of a long and civilized life as "joy-giving" and "life-enhancing."

In pursuit of that vision, The Phillips Collection is honored to share, with a broad national audience, through this exhibition, some of Duncan Phillips's most important acquisitions in the European tradition of painting and sculpture. We do so in the hope that, in the years to come, as your travels bring you to Washington, you will find your way to The Phillips Collection to linger among old acquaintances, from El Greco to Picasso.

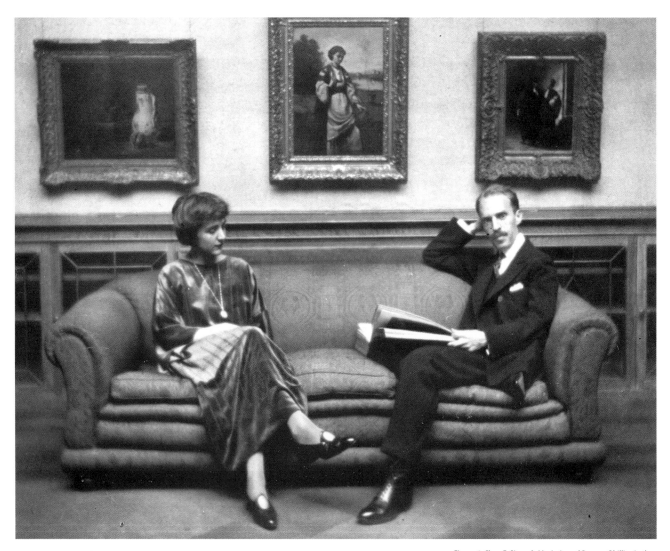

Figure 1. Clara E. Sipprel, *Marjorie and Duncan Phillips in the Main Gallery*, ca. 1922, gelatin silver print, The Phillips Collection, Washington, D.C.

Seeing Beautifully: A Vision of the Whole

Eliza E. Rathbone

"Art offers two great gifts of emotion—the emotion of recognition and the emotion of escape. Both emotions take us out of the boundaries of self

At my period of crisis I was prompted to create something which would express my awareness of life's returning joys and my potential escape into the land of artists' dreams. I would create a collection of pictures—laying every block in its place with a vision of the whole exactly as the artist builds his monument or his decoration."

These words written by Duncan Phillips in 1926 express his intense passion for works of art and his remarkable prescience in envisioning the collection he would create. "Laying every block in its place with a vision of the whole" was a project of extraordinary ambition that would take him a lifetime to achieve.

Every collector's achievement results from both intention and opportunity. When Phillips decided to create a museum of modern art and its sources, he set for himself the task of defining modern art and its origins in the art of the past. The image of building "his monument or his decoration," of "laying every block in its place," suggests working from the bottom up or starting with nineteenth-century "sources" and moving forward into the present. But Phillips's method was more akin to that of a painter than a stonemason. In fact, his fifty-year odyssey in collecting echoes the method of a late Cézanne: just as Cézanne made each stroke of color perfectly cohere into a unified whole, so Phillips retained his vision of the whole even as each piece—old master or modern, American or European—came into his collection. Many of the important source works were not acquired until the 1940s and 1950s, decades when he also continued his adventurous and active buying of contemporary art. The result is an exceptionally unified collection that perfectly reflects the evolution of Phillips's eye and taste, a collection in which the whole is greater than the sum of its parts. It may not be going too far to call it a work of art in itself.

Phillips was convinced that the collector should develop his own individual taste in art—to know which artists he admires and why. As early as 1907, while still an undergraduate at Yale and an editor of *The Yale Literary Magazine*, Phillips wrote an article expressing these views with great conviction and stating, "A man may succeed in memorizing a wide amount of book knowledge—yet if he is without the ability to understand, appreciate and possess opinions of his

"A joyous and abounding book which is sensitive to its finger tips."
— *The Bookman.*

The ENCHANTMENT OF ART AS PART *of* THE ENCHANTMENT OF EXPERIENCE

ESSAYS *by* DUNCAN PHILLIPS

Frontispiece in Color and Eight Reproductions from Photographs

Octavo, Cloth, $2.50 Net

"Full of keen estimates and genuine appreciation." —*The Independent.*

FOR SALE BY ALL BOOKSELLERS
JOHN LANE CO., *Publishers*, New York

Figure 2. Cover for *The Enchantment of Art as Part of the Enchantment of Experience, Essays by Duncan Phillips,* published in 1914. (A subsequent edition with revisions was published in 1927.)

own, he is not cultured." He continued with disparaging words about millionaires who buy collections through dealers, praising by contrast "the self-educated, hungry souled clerk who spends his half-holidays wandering blissfully through the galleries." Phillips took seriously the process of self-education. He read the leading critics of his day, Frank Jewett Mather, Roger Fry, and Clive Bell. Fry and Bell, who introduced postimpressionism to England and were deeply affected by it, provided a framework for Phillips's consideration of the roots of modern art. He pored over Roger Fry's collected essays in *Vision and Design* (1920), underlining lengthy passages, and consumed Bell's *Art* (1914), scribbling his own impassioned and engaged responses in the book's margins. Testimony to his deep absorption of Bell's ideas about art, aesthetics, and "significant form," his notes often begin with comments like "I heartily agree" and "Quite true!"

Phillips's urge to use his own literary skills to explore and express his ideas about art eventually led him to produce more than two hundred articles and essays and seven books. He also kept more than thirty journals and wrote some two hundred unpublished manuscripts, which constitute a remarkable record of his perceptions and the evolution of his collector's eye (fig. 2). But even as he studied the words of critics, Phillips understood early on the value of learning from artists how to look at art. He sought out the advice of several artists, including Arthur B. Davies and Augustus Vincent Tack, both of whom became close friends and advisers on looking at painting. He and his wife, Marjorie (fig. 1), made visits to many studios, always delighting in engaging directly with artists in discussions about art, both past and present.

Just as Phillips was clear about his own independence of judgment and spirit, he believed in artists who were similarly inclined. As he put it, "My own special function is to find the independent artist and to stand sponsor for him against the herd mind whether it tyrannizes inside or outside of his own profession." Phillips saw a work of art as an "intimate personal message" and in

this spirit determined to provide the works he collected with an intimate and personal atmosphere for their contemplation. By the middle of the 1920s, he had formulated his views about the appropriate setting for his collection, stating: "Instead of the academic grandeur of marble halls and stairways and miles of chairless spaces, with low standards and popular attractions to draw the crowds and to counteract the overawing effect of the formal institutional building, we plan to try the effect of domestic architecture, or rooms small or at least livable, and of such an intimate and attractive atmosphere as we associate with a beautiful home. To a place like that, I believe people would be inclined to return once they have found it and to linger as long as they can for art's special sort of pleasure." To this day, the galleries of The Phillips Collection have preserved their unassuming domestic scale, providing what Phillips recognized as a modest setting for a collection of unique character and exceptional distinction.

Indeed, Phillips's ambitions for the works of art he would collect were far from modest. As early as 1923, he envisioned "an American Prado." That same year the museum had become the proud possessor of Renoir's *Luncheon of the Boating Party*, a statement to the world of Phillips's lofty aspirations. His excitement is palpable in the letter he wrote to his treasurer announcing that the gallery was to be "the possessor of one of the greatest paintings in the world." He called the painting "the masterpiece by Renoir and finer than any Rubens—as fine as any Titian or Giorgione. Its fame is tremendous and people will travel thousands of miles to our house to see it. . . . Such a picture creates a sensation wherever it goes." In 1911 and 1912 Phillips had made trips to Europe, where he was transported by Renoir's work, warming to its "thrilling vitality" and "shimmering richness." With this single brilliant purchase, he put his fledgling collection on the map and set a course for the future. Now he was ready to state, "I could get lesser examples, which would give great satisfaction, but for such an American Prado as I am planning, there must be nothing but the best." To this day, the Renoir, beyond all other works in the collection, draws visitors to the house at 1600 Twenty-first Street and amazes those who did not anticipate finding it there (figs. 3, 5).

The 1920s was a decade of active buying and significant acquisitions. Among nineteenth-century French paintings, Phillips showed at this time a marked preference for landscape, the predominant subject of many of the great artists whose work he would collect. Even before the museum opened, he had acquired Monet's *Road to Vétheuil*. In the mid-1920s he further pursued his interest in

landscape by acquiring Alfred Sisley's *Snow at Louveciennes*; two superb landscapes by Gustave Courbet, *The Mediterranean* and *Rocks at Mouthier*; and Cézanne's *Mont Sainte-Victoire*. It would take Phillips thirty years to complete the extraordinary "unit" of works by Cézanne in the collection, culminating in 1955 with the acquisition of *The Garden at Les Lauves*, a late work that his eye and judgment were probably not yet ready for in the 1920s.

Honoré Daumier's *The Uprising*, purchased in 1925, signaled Phillips's deep response to works that deal with the human condition. Recognizing in Daumier a keen observer of human nature and a forceful satirist, Phillips also saw in him "a mystic," "a romantic poet," and "a technical experimenter far in advance of his age." *The Uprising*, one of Phillips's most prized purchases, was the largest of seven paintings by the artist that Phillips acquired, making his representation of Daumier as a painter among the finest in America. He gave the work boundless praise, writing, "Daumier's *The Uprising* is not only one of the greatest paintings of the nineteenth century but of all time. The titanic genius of its plastic power is worthy of comparison with Rembrandt . . . and Michelangelo."

Throughout the 1920s, after the collection opened to the public in 1921, the principal space for the exhibition of paintings was the Main Gallery, a skylit room designed by McKim, Mead, and White, in which Phillips mounted frequently changing installations. In hanging works by various artists of various schools in close proximity to each other, Phillips discovered relationships and "conversations" between artists of different periods and schools. Such insights must have had a formative influence on the development of his collection, leading to an anti-institutional and highly imaginative and flexible approach to installing it (fig. 4). Through unexpected juxtapositions, Phillips also hoped to stimulate the eye of the visitor. As he put it: "I avoid the usual period rooms—the chronological sequence My arrangements are for the purpose of contrast and analogy. I bring together congenial spirits among the artists from different parts of the world and from different periods of time and I trace their common descent from old masters who anticipated modern ideas."

Among those "old masters who anticipated modern ideas" were Jean-Siméon Chardin and El Greco, and Phillips was fortunate to find suitable works by both artists early in the development of his collection. He could hardly have found a more appropriate painting by Chardin than *A Bowl of Plums* to illustrate the great debt of nineteenth-century still life to the eighteenth-century master, or a more ideal subject than Saint Peter in El Greco, whose work was widely recognized at this time as anticipating the modern. Phillips would have been

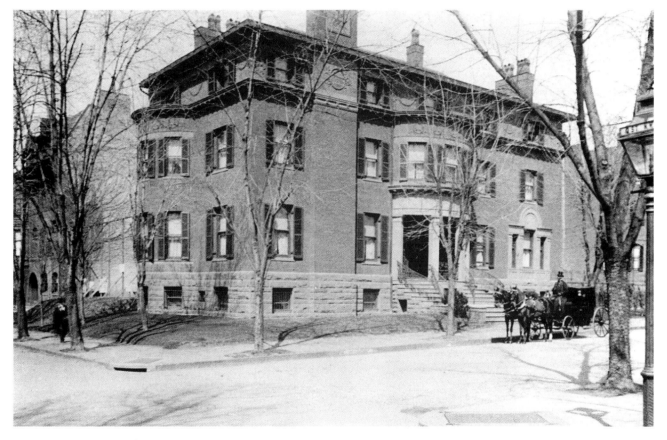

Figure 3. The house at 1600 Twenty-first Street,
NW, ca. 1900.

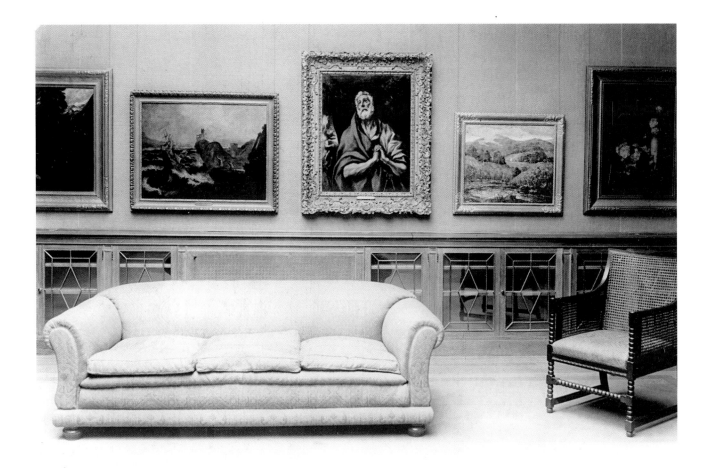

Figure 4. Main Gallery, 1920s.

aware of Roger Fry's report on the acquisition of an El Greco by the National Gallery in London in 1920, about which Fry wrote: "Mr. Holmes has risked a good deal in acquiring for the nation the new El Greco. . . . With [it] he has given the British public an electric shock. People gather in crowds in front of it, they argue and discuss and lose their tempers. . . . It is really about the picture that people get excited. And what is more they talk about it as they might about some contemporary picture. . . . That the artists are excited—never more so— is no wonder, for here is an old master who is not merely modern, but actually appears a good many steps ahead of us, turning back to show us the way."

Phillips was entirely attuned to Fry's point of view. Later in the 1920s, he wrote an essay about El Greco, Cézanne, and Picasso, in which he hailed El Greco as an important antecedent to Cézanne. He admired El Greco for his

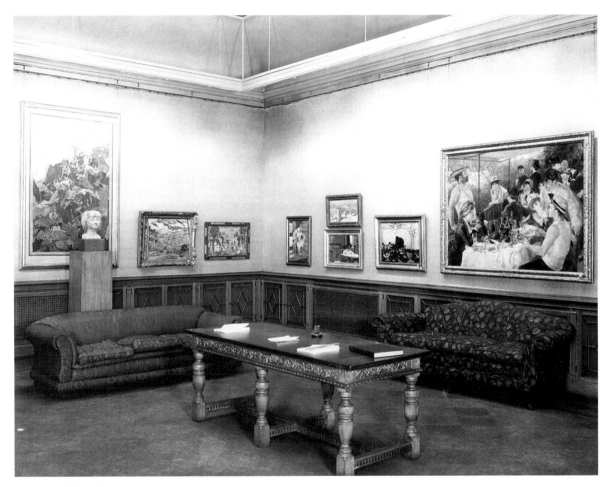

Figure 5. Main Gallery, early 1930s.

"art of building forms in space, a science of projecting and receding planes, a movement of those lines which had emotional force and meaning in them, an enlargement of the unit of design until every mark of the brush, every modulation of color, and every swirl of line repeated one insistent rhythm." He found the final phase of this idea in Picasso. In the end, he felt that "Cézanne would not have altogether approved of his disciple Picasso. At least in his ripe maturity he was too sober a classicist to have tolerated fanaticism when it frankly threatened the sanctity of his museums and traditions and implied infidelity to his beloved Nature. Of the three baroque painters only Greco and Picasso are of the same Gothic family." Bearing out his aesthetic judgments, Phillips often installed El Greco's *The Repentant St. Peter* and Picasso's *Blue Room* near each other in his galleries.

Nonetheless, Phillips's excitement over analogies would not produce a perfect work to compare and contrast to El Greco's *The Repentant St. Peter* until fourteen years later, when Goya's *The Repentant St. Peter* came on the market in 1936. Indeed, the chance availability of this painting, which provided Phillips with the rare opportunity to purchase a major work by the artist, created an art historian's dream of comparing and contrasting the same subject in the hands of two distinctly different harbingers of the modern.

To obtain the Goya, Phillips traded a Tahitian landscape by Paul Gauguin. This was neither the first nor the last time he parted with one acquisition to make another. The marvel to us today is that as he made difficult choices, he honed his collection, seeking internal relationships, and moved toward securing greater examples of the artists he admired. No one can deny, for example, that Gauguin's *Ham*—in many ways an atypical work, which Phillips had the great good fortune to acquire in 1951 from New York dealer Paul Rosenberg—is one of the artist's greatest still-life paintings and far superior to the Tahitian landscape that Phillips let go. Phillips recognized the still life's superior quality, prompting him to write to Rosenberg, "In spite of the fact that we cannot really afford an expensive picture at this time the Gauguin *Le Jambon* has such a resemblance to the Collection and is so much needed as a source of subsequent painting that we cannot resist it." He similarly gave up two paintings by Matisse to obtain Georges Rouault's *Verlaine*, a superb example by an artist Phillips greatly admired. This could be viewed as a mistake were it not for the two works by Matisse that Phillips retained, the great *Studio, Quai St. Michel* of 1916 and *Interior with Egyptian Curtain* of 1948, both paintings that stand as major landmarks in the artist's work.

From first to last, Phillips felt an intense response to the role of color in works of art. In the 1920s he discovered an astonishing colorist in the French painter Pierre Bonnard, initiating a great romance with the artist's work that would continue throughout his life as a collector. In Bonnard Phillips recognized an heir to Renoir. Of the artist's work, Phillips wrote, "Bonnard is the supreme sensitivity, the music-maker of color. Each of Bonnard's pictures is a personally chosen fragment of a world of his own discovery day by day. Each is a fastidious record of some immediate and intimate visual occurrence to which his eye, mind and hand had been at one time or another dedicated." While other major institutions like the Museum of Modern Art viewed Bonnard as a latter-day impressionist and strongly favored Picasso and Matisse, Phillips chose Bonnard's work to collect in depth and went on to acquire a group of

paintings by Bonnard that remains unrivaled in America (fig. 6). Aware of the independence of his choice, he wrote for *Art News* in 1930 words that continue to ring true for many artists today: "No matter how original such great individualists as Bonnard and John Marin may be, how rare and inimitable their vision, how subtle and sure their intuition and awareness of nature, how incommunicable the secret of their touch, there is no sympathy for such individualism and for such independence as they display." Phillips's enthusiasm for Bonnard's work was also entirely consistent with one of his first loves in American art, the paintings of Maurice Prendergast. Finding in both artists an individual approach to color, he saw in them an instinct for the decorative that he greatly admired.

Often it appeared that Phillips's engagement in collecting contemporary art gave insight to his choice of works by earlier masters. Indeed, living with Bonnard's original and brilliant chromatic harmonies and splayed compositions may have led to Phillips's eventual acquisition in the 1940s of the daring late work by Degas, *Dancers at the Bar*, in which the intense vibration of orange-red tonalities and the modulated blue-green of the dancers' skirts combine with a dynamic composition. Indeed, Phillips acquired all the paintings in his collection by Degas—with the exception of a painting of a ballet rehearsal, which he gave to Yale University—in the 1940s, a time when he was keenly engaged in contemporary acquisitions. Works by Delacroix and Ingres, key sources for Degas himself, were also purchased in the 1940s. Similarly, paintings by Nicolas de Staël, with their patches of color and abstract harmonies, preceded Phillips's purchase of Cézanne's *Garden at Les Lauves*, a work in which he saw an immediate correspondence. As he put it, the kinship with Cézanne's late work could be observed in de Staël's "improvising with his masonry of color shapes" and his continual search for both structure and rhythm.

Having opened the collection to the public in the fall of 1921 with approximately two hundred works that he had acquired between 1916 and 1921, Phillips had by 1930 acquired approximately three hundred more works for his growing museum. In his 1930 article for *Art News*, Phillips stated, "With those of us who pride ourselves on open-mindedness the incessant innovations in painting keep us actively entertaining new ideas and violently exercising our adaptability." At this time Phillips had begun collecting art by young Americans like Arthur Dove, Milton Avery, and Georgia O'Keeffe, whose works were far less generally sought after than the new painting being done in France. So he could turn the entire house on Twenty-first Street over to his art gallery, Phillips decided to build a house for himself and his family on Foxhall Road,

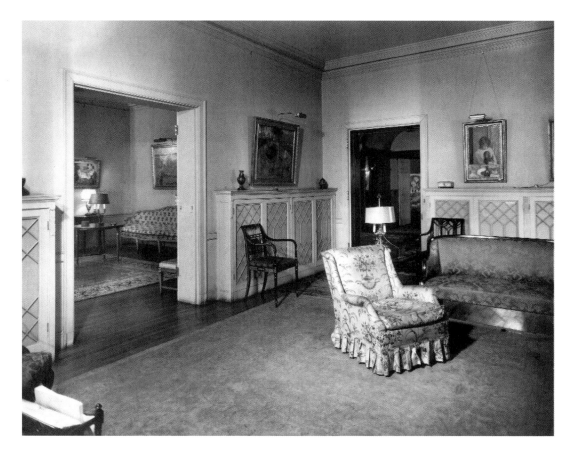

Figure 6. Little Library (with Bonnard's *Woman with Dog*, and Gauguin's *Idyll of Tahiti*, 1901) looking into the Drawing Room (with Bonnard's *Early Spring* and Picasso's *The Blue Room*), ca. 1930. Photo: Buckingham Photographers of Fine Arts

farther from the center of Washington (fig. 8). In 1930 he celebrated the opening of the house on Twenty-first Street as his museum by making a major purchase, Vincent van Gogh's *Entrance to the Public Gardens in Arles*, the first painting by van Gogh to enter his collection. An article in the Washington *Sunday Star* announced the opening of the entire house and the first opportunity for Washingtonians to see the painting by van Gogh, which had also been shown the year before at the opening exhibition of the Museum of Modern Art in New York.

That van Gogh's *Public Gardens* was shown at both museums so close in time is hardly surprising. The two collections had remarkably similar missions. When the Museum of Modern Art opened in 1929, its first statement of purpose echoed Phillips's in describing its intention "first of all to establish a collection of the immediate ancestors of the modern movement," whom it identified with the major figures of postimpressionism—Cézanne, Seurat, Gauguin, and van Gogh. Because Phillips had been working with these ideas for the better part of a decade, he was a natural choice as a founding member of the Museum of Modern Art's board of trustees.

Phillips's discerning eye and remarkable achievement likewise led to an

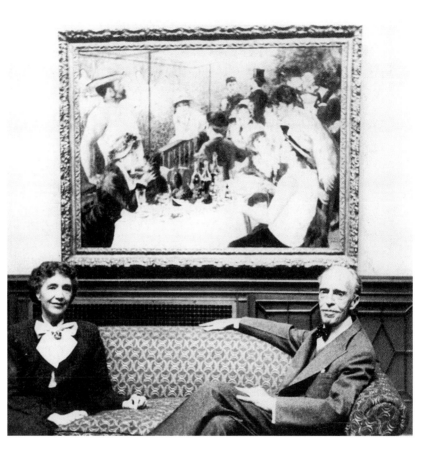

Figure 7. Duncan and Marjorie Phillips in front of Renoir's *Luncheon of the Boating Party* (1881), ca. 1954. Photo: Naomi Savage

appointment to the first board of trustees of the National Gallery of Art in Washington, which opened in 1941. Unlike Phillips, however, the National Gallery would only begin to accept for exhibition the works of living artists in 1965, when the Chester Dale bequest, which included outstanding works by Picasso, compelled the museum to rethink its policy. By this time, Phillips had already been collecting contemporary art for four decades.

Given Phillips's reputation in the art world, it was natural that Katherine S. Dreier, one of the most avant-garde collectors in America and founder of the Société Anonyme, held him in high esteem. Although they first met in New York in 1941, both Phillips and Dreier had been assembling extraordinary and distinctly different collections of contemporary art since the 1910s. Phillips had given a work by Arthur Dove to the Société Anonyme and had purchased a painting by Juan Gris (*Still life with Newspaper*, 1916) from Dreier in 1950. In 1953 The Phillips Collection was greatly enriched by a gift of seventeen works from Dreier's estate. When Marcel Duchamp, the executor of Dreier's estate, offered Phillips an extensive list of works for his museum, Phillips stated his "preference to accept only such works as relate in one way or another to the whole scope and yet the very personal taste of my collection." The choices Phillips made

reveal the extent to which his personal taste and vision for his collection could
not be swayed, even by an offer of major works by famous artists. He rejected,
for example, a sculpture by Constantin Brancusi and allowed Alfred Barr to
persuade him to let Duchamp's *Small Glass* (1918) go to the Museum of
Modern Art. But the works that Phillips selected by Franz Marc, Wassily
Kandinsky, Kurt Schwitters, Piet Mondrian, Alexander Archipenko, Georges
Braque, and Alexander Calder, among others, are superb examples by these
artists, which strengthened his collection immeasurably.

Serendipity always plays a part in collecting, and Phillips gained some great
acquisitions through unexpected friendships and connections. The two other
paintings by van Gogh that Phillips purchased, *The Road Menders* and *House at
Auvers*, came from the collection of a longtime friend, Elizabeth Hudson.
Phillips was aware of the quality of the works she possessed, and when she
decided to sell her paintings by van Gogh in 1949, he seized the opportunity
to buy them. The result is an essentially ideal group of paintings by van Gogh,
including a work from each location of the artist's mature life—Arles, Saint-
Rémy, and Auvers.

While some purchases were the result of unforeseen opportunity, Phillips
also very deliberately singled out certain artists to collect in depth. (Naturally,
not all hoped-for opportunities came his way. For example, Phillips never
realized his dream of acquiring a painting by Rembrandt.) Never concerned
with creating a comprehensive collection that would serve to document a period
or movement, he sought instead to capture the individual artist's voice, and if
it spoke to him, his devotion was steady. In his initial plans for his museum, he
had envisioned individual rooms devoted to a single artist, but over time only
two artists, Paul Klee and Mark Rothko, claimed spaces as quasi-permanent
installations of their work. Enchanted by Klee's highly personal imagination,
Phillips assembled between 1938 and 1948 thirteen works that chronicle the
artist's production from 1924 to 1938. On the second floor of the house he
created a windowless, featureless room dedicated exclusively to Klee's work.
There, one entered a world of Klee's own measure and dimension, a world
where, as Phillips put it, "Klee builds himself a little house of art in a realm
somewhere between childhood's innocence and everyman's prospect of infinity."

Phillips's continuing interest in contemporary art led him in the 1950s to
explore the work of many new and emerging talents, both American and
European, including de Staël and Pierre Soulages, as well as Willem de Kooning,
Bradley Walker Tomlin, Mark Tobey, Kenzo Okada, and Rothko. The large-size

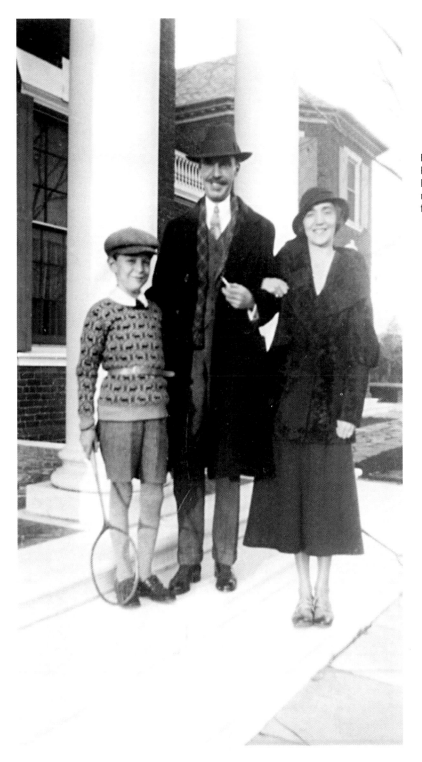

Figure 8. Duncan, Marjorie, and Laughlin Phillips on the steps of their home, Dunmarlin, on Foxhall Road, ca. 1932. The name of the house incorporated elements from their names.

canvas often favored by these artists, together with the increasing growth of the collection as a whole, spurred Phillips to initiate the construction of another building for the collection that would be joined to the original house by a two-story bridge. The Annex, designed by Frederick Rhinelander King with a good deal of input from the Phillipses themselves, opened to the public in 1960 (fig.9). Its galleries were planned to echo the scale and feel of the original house, and a room was set aside on the first floor for Rothko's paintings, the first realization of an ideal that the artist had harbored for many years. In this case, unlike the Klee room, Phillips had the benefit of conversations and visits with the artist himself, and the close understanding that developed between them led to the creation of one of the most successful rooms devoted exclusively to Rothko's work. By this time, each artist that Phillips took on contributed a voice that could participate in the visual "conversations" already established in the collection. Phillips's strong response to Rothko's work seems adumbrated by a host of works in the collection—from William Merritt Chase's *Hide and Seek*, with its daring void in the center of the composition, to Bonnard's finely tuned color harmonies, echoed in Rothko's more brooding and emotive work. Likewise, the work of American Richard Diebenkorn seemed ideal for inclusion in a collection where he had spent many hours absorbing the compositional inventions of Edouard Vuillard and the sober monumentality of Matisse's *Studio, Quai St. Michel.*

By careful selection, Phillips achieved to a rare degree the unity in diversity that he sought for his collection. In his "experiment station," he combined the independence of the private collector with the ideal of serving the public. To his youthful romanticism, he brought an understanding of formalist concerns, forging a profound appreciation of the strengths of both. His collection had been, as he put it, "lived with, worked with, and loved." As a collector, writer, and museum director, Phillips's most earnest purpose was to share his own pleasure in the life-enhancing power of art. As he explained it late in life, with characteristic modesty:

"Pictures send us back to life and to other arts with the ability to see beauty all about us as we go on our accustomed ways. Such a quickening of perception is surely worth cultivating. I have devoted myself to the lifelong task of interpreting the painters to the public and of gradually doing my bit to train the public to see beautifully."

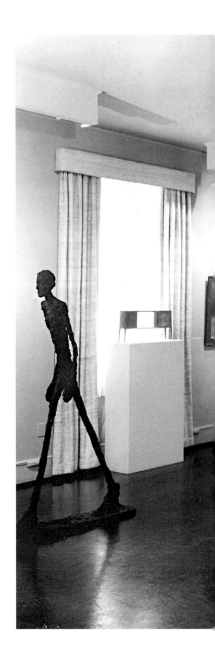

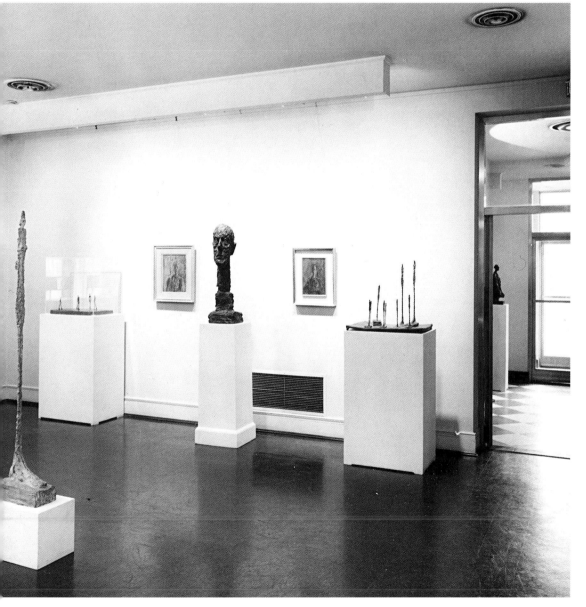

Figure 9. "Alberto Giacometti: A Loan Exhibition", February 7 – March 18, 1963, in the galleries of the first floor of the Annex.

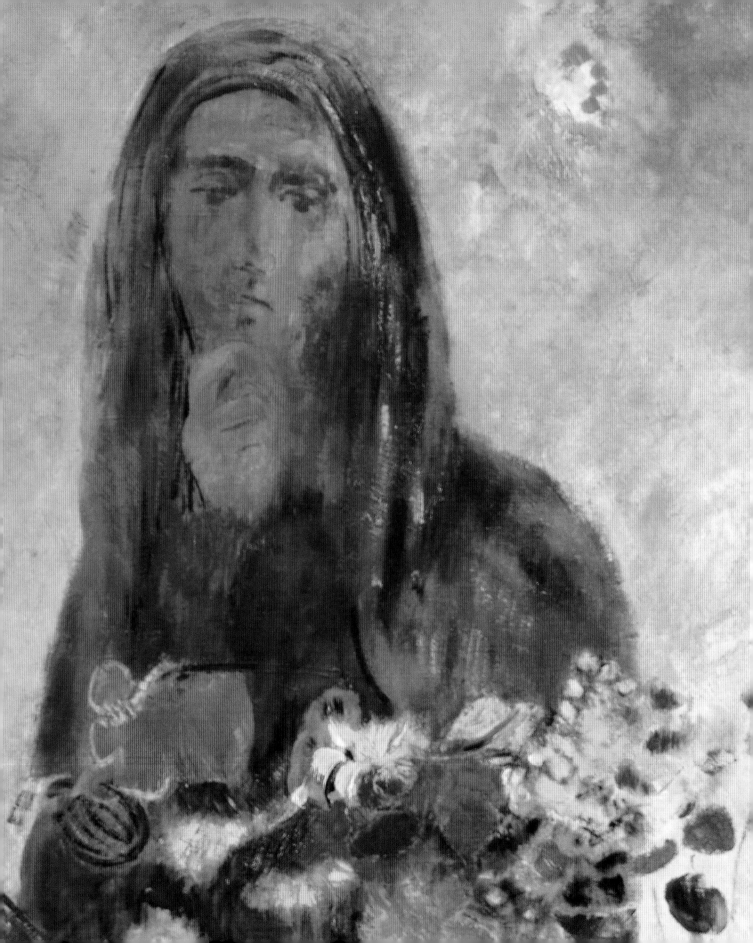

Paintings and Sculpture

Pierre Bonnard

b. 1867, Fontenay-aux-Roses, France, d. 1947, Le Cannet, France

At the start of his career Bonnard, along with his friend Edouard Vuillard, belonged to the Nabis, a group of painters who embraced the symbolist theories of Paul Gauguin, Japanese art, and the poetry of Stéphane Mallarmé. Where Gauguin looked to distant civilizations and lost Edens for meaningful symbols, Bonnard found paradise at home. Unlike the impressionists, to whose work Bonnard's has a superficial resemblance, Bonnard worked from memory rather than from the motif, which accounts for the dreamlike quality of his paintings. His quiet and private life is mirrored in his work. Bonnard's primary subject was the domestic interior and its psychological charge. He peopled his works with family members, particularly Maria Boursin, who called herself Marthe de Méligny. She became Bonnard's mistress in 1893 and was his wife from 1925 until her death in 1942.

The first painting by Bonnard Duncan Phillips acquired was *Woman with Dog*. It was a revelation to Phillips who saw it at the annual Carnegie International exhibition in Pittsburgh in 1925 and bought it, along with another of Bonnard's earlier works the same year. Here is Marthe dressed in a red blouse with white stripes, seated meditatively, at a table with the remains of a meal before her and, on her lap, a brown dachshund. Bonnard, whose household always included dogs, understood pets as essential threads in the weave of human life. Dogs and cats insinuate themselves into his paintings, often showing up at the edges of the canvases. Part of Bonnard's calligraphy, and not always immediately decipherable, they function as marks at the periphery of the viewer's vision. His dogs and cats quietly lay claim to laps, sofas, and scraps of food. In *Woman with Dog*, however, the dog is central to the composition, forming with the bottle and the post in the background, the vertical boundaries of the shallow space behind the table where the figure of Marthe is confined. The ravishing colors of the painting, unified by shimmering, pearly light, are typical of Bonnard.

Bonnard used color both expressively and scientifically, setting the mood of a scene, and, at the same time, accurately describing the way the eye encounters particular effects of light. In *The Palm*, the landscape, with its decorative, tightly woven, abstract pattern of rooftops seen through a frame of palm fronds, is a vista Bonnard could see from his home on the French Riviera. The artist was keenly observant of the tricks light plays and the way the eye apprehends the world as opposed to the way one actively looks at pictures. In *The Palm* Bonnard places the painting's human subject at the bottom of the picture, which evokes the experience one has when, dazzled by bright light, one's eyes do not instantly adjust to shadow. Looking at *The Palm*, one focuses first on the light-filled view in the center of the composition, not immediately noticing the drama quietly taking place in the foreground shade. There, the half-figure of a woman looks out at the viewer, an apple in her hand, which seems almost to cross the frame of the painting into the viewer's space. Is she Eve offering the apple? Is she an allegory of nature? Or, do the palm fronds signify victory? If so, perhaps, Bonnard is saying that the model, possibly Marthe, is beauty herself, Venus Victrix on Mount Ida, to whom Paris has just awarded the golden apple.

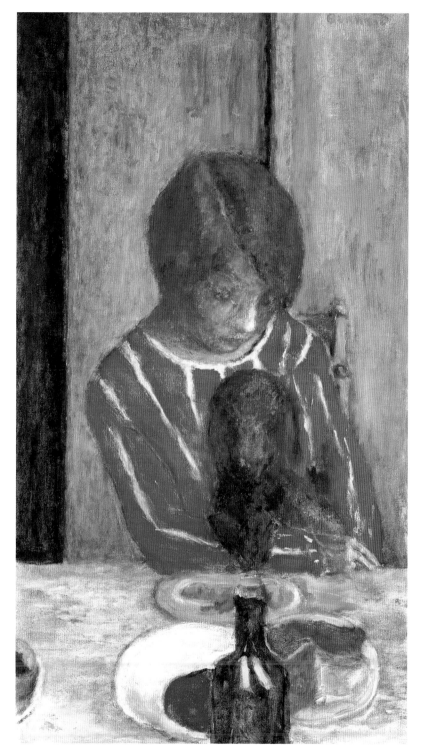

Woman with Dog, 1922
Oil on canvas
27 ¼ x 15 ⅜ inches
(69.1 x 39 cm)
Acquired 1925

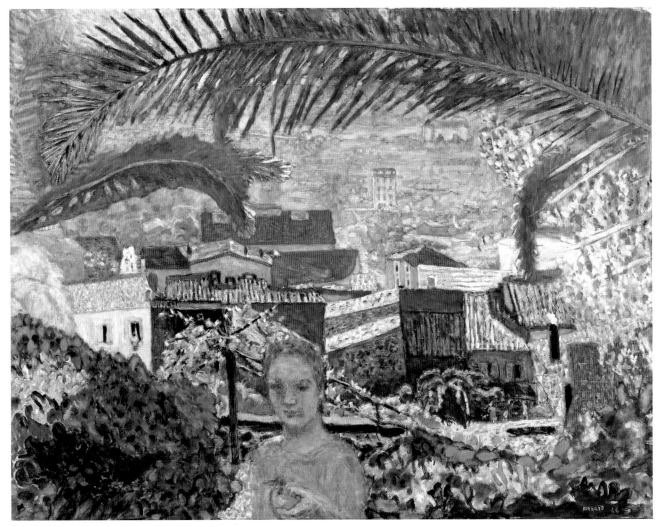

The Palm, 1926
Oil on canvas
45 x 57 ⅞ inches
(114.3 x 147 cm)
Acquired 1928

It is hard to overstate the importance to The
Phillips Collection of Phillips's encounter with
Bonnard's work in 1925. Bowled over by the
artist's expressive use of color, Phillips saw in his
paintings a modern continuation of the sensualist
tradition of Titian and Pierre-Auguste Renoir.

Georges Braque

b. 1882, Argenteuil-sur-Seine, France, d. Paris, 1963

With one exception, the thirteen paintings by Braque in The Phillips Collection date from the years following the end of the pioneering cubist examinations of space and form he undertook with Pablo Picasso. Called up at the beginning of the First World War and seriously wounded in 1915, Braque returned to painting in 1917, at which time he and Picasso were no longer "two climbers roped together," as Braque described their earlier partnership. Braque continued to use the pictorial language and images of cubism but in ways that made the subjects of his paintings intelligible. Although appalled by the first manifestations of cubism, Duncan Phillips developed an understanding of the style by the end of the 1920s, in large part because Braque's seductive paintings themselves so changed the look of cubism. During the 1920s, his paintings became majestic and grave, which led Phillips to see in them supremely French "qualities of taste, logic and balance."

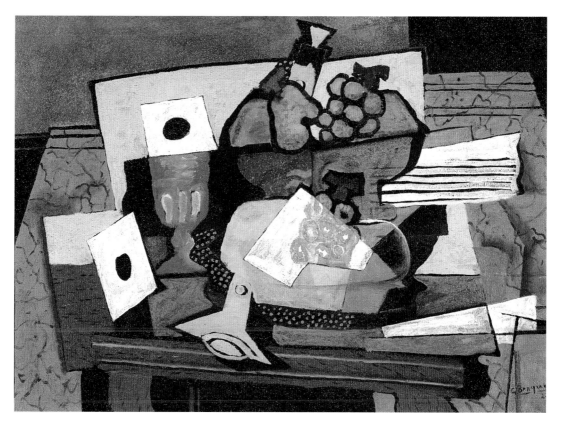

Still Life with Grapes and Clarinet, 1927
Oil on canvas
21 ¼ x 28 ¾ inches
(53.9 x 73 cm)
Acquired 1929

Still Life with Grapes and Clarinet is a particularly satisfying example of Braque's formal, compositional stability coupled with exquisite color harmonies worked out in an austere, restricted, and elegant palette of black, white, ochre, and green. Using motifs from the repertoire of early cubist still lifes, such as playing cards, musical instruments, and fruit, Braque sets the non-illusionistic naturalism of certain elements, like the fruit, against the abstraction of others, for example, the playing cards. Marble and wood-grain surfaces, here simulated in paint rather than the actual pasted wallpaper Braque used in his earlier *papiers collés*, are among the many allusions to the sense of touch in *Still Life with Grapes and Clarinet*. They recall the importance that the tactile held for Braque. "We must make [people] want to touch," he said. Objects themselves had no particular significance for him. They were interesting simply as elements in compositions, occupants of what Braque called "tactile space," the space between them and us.

In the 1920s Braque worked on a series of still-life paintings with emphatically horizontal formats. *Lemons and Napkin Ring*, a study for a marble mosaic commissioned for his dealer's dining room in Paris, is about three times as wide as it is high. The resulting vertical compression affirms the painting's identity as an object itself. Painted in a limited and dark palette of black, white, brown, and yellow, the narrow strip of canvas is like a shelf with objects on it. The objects themselves—three lemons (two of them on a white dish), a pitcher, a rolled napkin in a napkin ring, and a cloth—occupy this restricted space and assume, in places, the character of

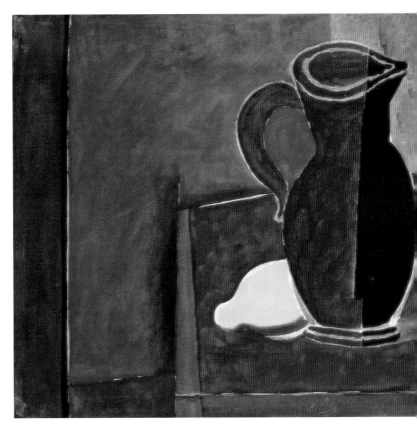

Lemons and Napkin Ring, 1928
Oil and graphite on canvas
15 ³/₄ x 47 ¹/₄ inches
(40 x 120 cm)
Acquired 1931

bas relief. At the same time the proportions of the canvas emphasize its flatness.

The Round Table is one of many still lifes that Braque set on a round pedestal table during the 1920s. He shows the table in a corner, its top tilted almost parallel to the picture plane and cluttered with objects. Throughout the painting, ambiguous spatial relationships cause the eye to shift as it moves over the canvas. Contrary to the laws of conventional perspective, the lines of the dado remain at a uniform height as they converge on the corner of the room. Abstracted pages or sheets of paper on the table seem to be interleaved with the planes of the corner. Half of the guitar appears three-dimensional, while the other half is two-dimensional. The knife—a staple of the still-life tradition in which it signified the painter's power as an illusionist— has its handle turned towards the viewer and is painted in two dimensions only. As a further reminder that paintings are artifice and canvas is flat, Braque paints the table to look as though it is cut out of wood-grained paper. He treats the dado, too, as though it is a fictive element, the creation of a house painter-decorator (a trade Braque learned from his father). The subject of *The Round Table* is an abstraction, the nature of painting, which Braque realized in a composition that shares the quiet, reserved quality of works by Chardin. Braque counters the unstable relationships between the objects in his painting with a centered and quartered composition that is powerfully, reassuringly, thoughtfully static. Painted with a light-filled palette of sensual, soft, pale viridian green, red orange, cobalt blue, and lemon yellow, as well as his signature blacks and whites, *The Round Table* invites the viewer's gaze to linger.

The Round Table, 1929
Oil, sand, and charcoal on canvas
57 $\frac{3}{8}$ x 44 $\frac{3}{4}$ inches
(145.6 x 113.8 cm)
Acquired 1934

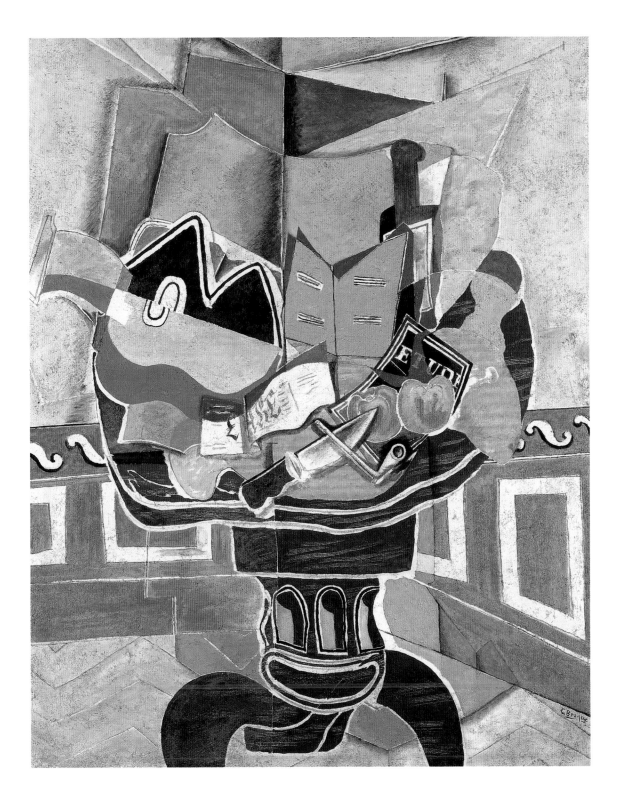

Paul Cézanne

b. 1839, Aix-en-Provence, France, d. 1906, Aix-en-Provence

Coming to terms with the art of Cézanne led Duncan Phillips to understand modern art. The collector considered the painter a fool in 1912, but later saw him as heir to El Greco and father of Pablo Picasso. Between 1925 and 1955, Phillips bought seven works by Cézanne that are now in The Phillips Collection (six oils and a lithograph). All date from the last twenty-eight years of the artist's life.

Here is Cézanne, aged about forty, at a point in life that invites self-appraisal. Cézanne painted scores of self-portraits, many of them in exactly this pose and on canvases of about the same size, recording the way he looked, his self-image, and his progress as a painter. In this powerfully modeled portrait, Cézanne looks at himself unflinchingly, objectively reporting his knobby features and generally lumpen, unrefined, and shaggy appearance. His jacket, loosely and roughly painted, seems, in places, to be of the same fabric as the canvas. Cézanne's hair reaches his collar and his neck is hidden behind his clothing and his messy beard. A hint of mouth is visible, but moustache and beard conceal most of it. Little skin shows. Cézanne models his ruddy, blotchy face and large, balding head in short unblended brushstrokes, built up to a thick impasto. This literal edifice of paint serves as a defense, behind which his sharp eyes peer out. It is the psychological guardedness of this man (otherwise, completely candid about his ugliness) that makes the painting so compelling. Vigorously and freely painted in a dark and limited palette, his work has more in common with the old masters than with impressionism. The Phillips Collection's painting was the first Cézanne self-portrait to enter an American museum. Phillips was very proud of it, describing "that head of an old lion of a man, the pride and loneliness of him so directly conveyed by purely plastic means." Curiously, Phillips was almost exactly the same age as Cézanne when he bought the painting, and only a little older when he wrote those words. History shows that, at forty, both men were just getting started.

One of the many views Cézanne painted of the mountain near his home in Aix-en-Provence, *Mont Sainte-Victoire* appears through a frame of pines and across a great valley. Cézanne may have loved the mountain, but his feeling for it differed from the visceral attachment that Gustave Courbet felt for his local scenery. For Cézanne, trysts with Mont Sainte-Victoire represented his ambitious struggle to paint landscapes for the ages and create new equivalents to the arcadian scenes of Claude Lorrain and Nicolas Poussin. Cézanne did not work quickly or easily. He painted Mont Sainte-Victoire like his still lifes, with deliberation, in short angled brushstrokes, trying to connect his visual sensations, not to a moment, but to the ongoing facts of the view. He sought to reconcile individual facts in his field of vision with the geography of the whole.

Cézanne's name is synonymous with still life. During his long wait for the right one, Phillips turned down several before receiving *Ginger Pot with Pomegranate and Pears* from his nephew. The work reprises objects seen in many of the still lifes Cézanne painted in Aix: a floral-patterned cloth hanging in the background, ginger pot, bowl, two tables, orange-striped white dishtowel, books, and fruit. They possess no significance for

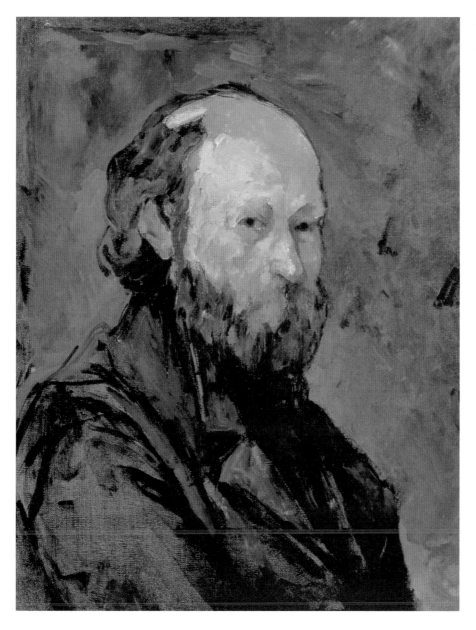

Self-Portrait, 1878–80
Oil on canvas
23 ¾ x 18 ½ inches
(60.4 x 47 cm)
Acquired 1928

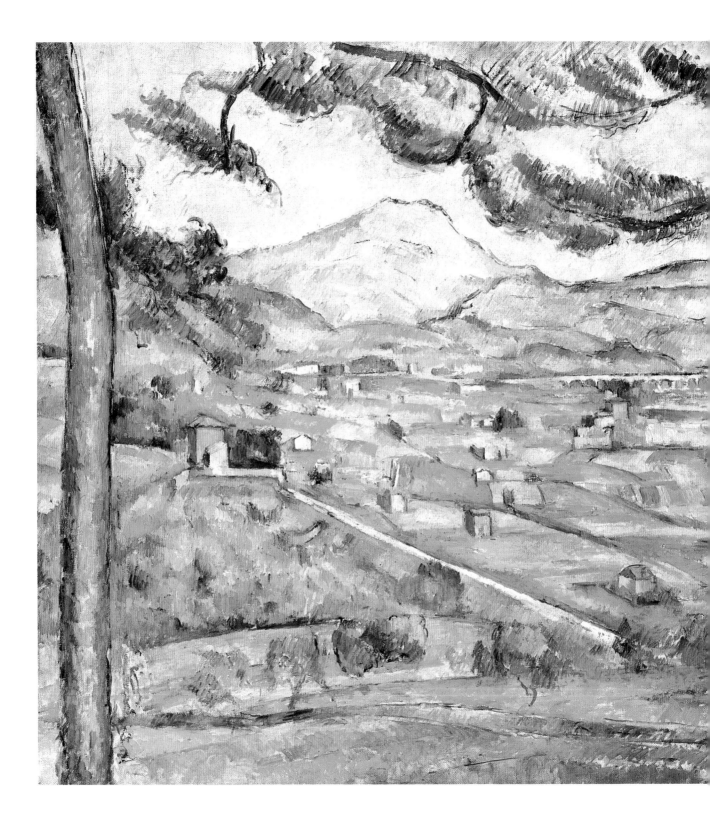

Mont Sainte-Victoire, 1886–87
Oil on canvas
23 ¹⁄₂ x 28 ¹⁄₂ inches
(59.6 x 72.3 cm)
Acquired 1925

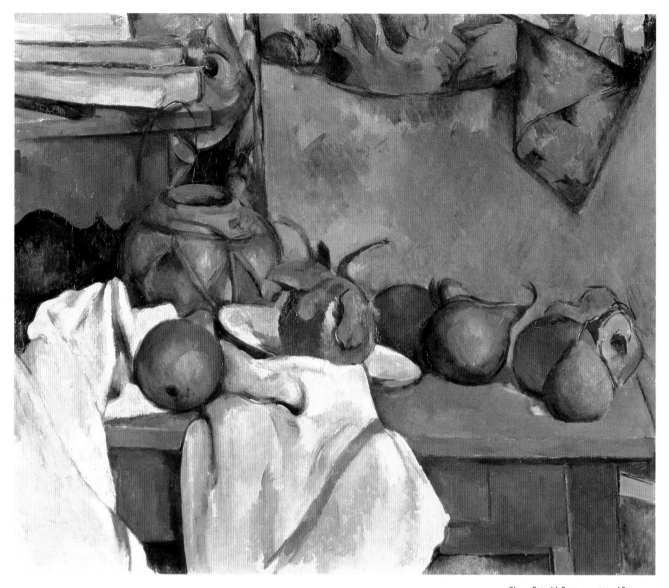

Ginger Pot with Pomegranate and Pears
1890–93
Oil on canvas
18 1/4 x 21 7/8 inches
(46.4 x 55.6 cm)
Gift of Gifford Phillips in memory of his
father, James Laughlin Phillips, 1939

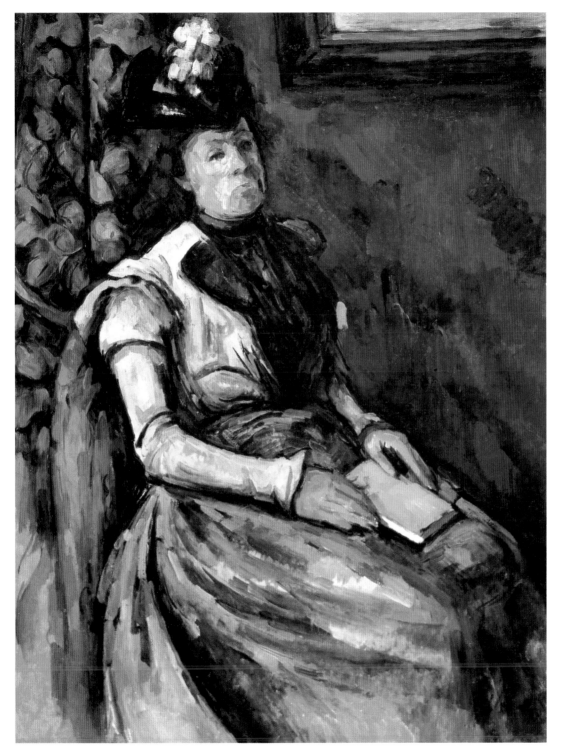

Seated Woman in Blue
1902–04
Oil on canvas
26 x 19 ¾ inches
(66 x 50.1 cm)
Acquired 1946

Cézanne except as elements of a compositional challenge that he set for himself. He insists on the convexity of all bodies in space, including surfaces, such as walls. By constant alternation of warm and cool colors, Cézanne gives his objects volume. Thick paint lends the fruit, in the center, and the folds of cloth near them further solidity. Below the patterned cloth, an empty area of blue wall occupies much of the center of the painting, indeed, almost appearing to curve in response to its surface treatment with dappled warm and cool colors laid on in the artist's characteristic short, angled strokes.

Seated Woman in Blue incorporates two of the props Cézanne used in *Ginger Pot with Pomegranate and Pears,* the flowered cloth and yellow book. The identity of the sitter wearing a blue dress and fancy hat is not known. Possibly, the painting depicts Cézanne's housekeeper, Madame Brémond. Whoever she is, her expression of tired endurance demonstrates that in his paintings Cézanne clearly distinguished between life and still life. It also shows the artist's heightened sensitivity to mood. Here, he conveys resignation and weariness by the motionless sitter's face and posture, as well as the contrast of the lively strokes with which Cézanne painted the wall and the sitter's skirt.

Energetically painted very late in the artist's life, *The Garden at Les Lauves* depicts a view towards Aix, which Cézanne could have seen from the studio that he built in 1901 north of the town. Framed by an overhanging branch of a tree that grew outside his studio, the vividly colored, abstracted view takes in the dark band of the terrace's retaining wall, beyond it, a middle ground of vegetation, and, in the distance, wild sky and perhaps mountains. Unpainted patches of canvas are visible among the slashes of color, leading scholars to speculate that this may be an unfinished work. However, the artist wrote in 1905 that he found "the color sensations which give us light are the source of abstractions which do not allow me to cover my canvas nor to pursue the delineation of objects where the points of contact are tenuous, delicate; thus my image and picture is incomplete." Phillips thought it a sketch, recognizing the painting's structure as well as its improvisational quality, and judged it a symbol of great art in the making.

The Garden at Les Lauves, ca. 1906
Oil on canvas
25 ¾ x 31 ⅞ inches
(65.4 x 80.9 cm)
Acquired 1955

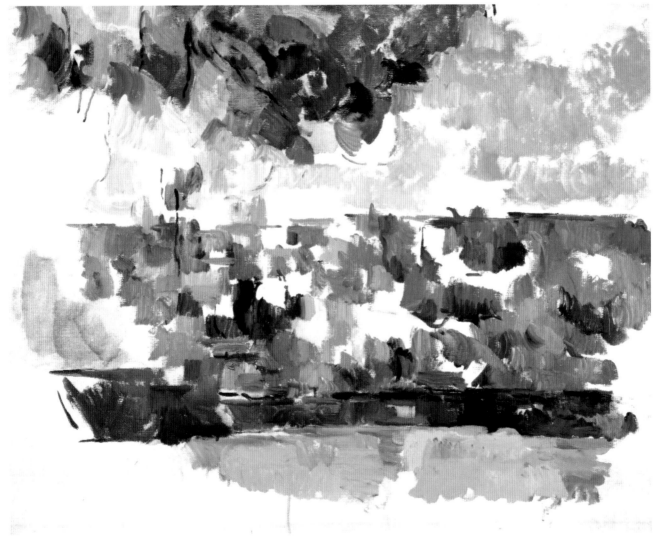

Jean-Siméon Chardin

b. 1699, Paris, d. 1779, Paris

Although himself an Academician, Chardin worked almost exclusively on subject matter that ranked very low in the official academic hierarchy of painting. Chardin spent most of his quiet and uneventful life painting luminous still lifes in glowing colors. He gave them up only for about a decade, starting in the mid-1730s, to concentrate on interior scenes, which commanded higher prices than still lifes. Chardin's work anticipated modernism in many ways. His originality lay partly in his choice of everyday objects as subject matter. The same cast of objects, typical of a bourgeois household, reappears in his works. The simple forms and humble nature of the objects, in apparently uncontrived arrangements, and Chardin's bold use of empty space give his work an austerity that sets it apart from the extravagance of contemporary rococo painting. *A Bowl of Plums* is typical of Chardin's early paintings. The bowl of fruit and the Delft pitcher are set on an indeterminate surface against a scumbled background and at enough distance to diminish detail, allowing a painterly concentration on essences rather than exact imitation. *A Bowl of Plums* was one of Duncan Phillips's favorite paintings. He admired it as "personal and poetic in spite of its apparent objectivity."

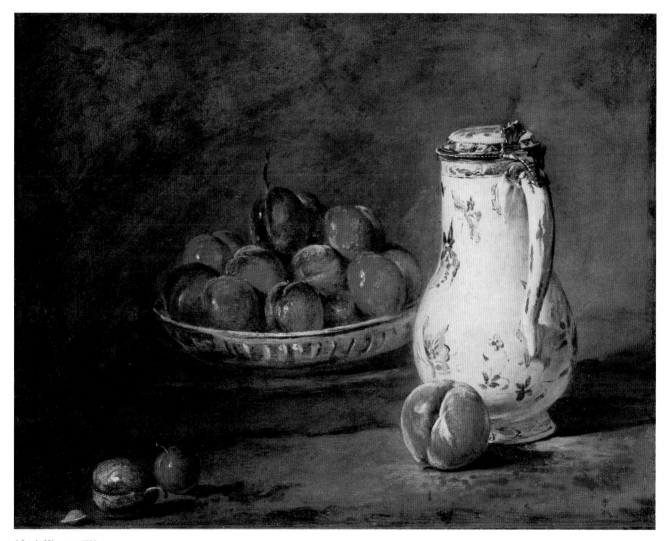

A Bowl of Plums, ca. 1728
Oil on canvas
17 ½ x 22 ⅛ inches
(44.6 x 56.3 cm)
Acquired 1920

John Constable

b. 1776, East Bergholt, England, d. 1837, Hampstead, England

Constable grew up in Suffolk, near the place depicted in *On the River Stour*. Suffolk held great personal meaning for him and, long after he had moved away, its landscape continued to serve as his subject matter. The house in the painting belonged to Willy Lott, a farmer who lived there all his life. It became Constable's symbol of continuity and a primary motif in his paintings. *On the River Stour* is one of several works that grew out of *The White Horse* (Frick Collection, New York), a large work of 1819 that garnered critical praise and secured Constable's reputation. Of *The White Horse*, Constable said, "There are generally in the life of an artist perhaps one, two or three pictures, on which hang more than usual interest—this is mine." *On the River Stour* omits the white horse and the barge that appeared in *The White Horse*. Other figures have replaced them: the man in

the river and the boat with a figure in the background. Its style is typical of Constable's late works in which his rendering of natural appearances became looser and gave way to a type of expressionism that verges on abstraction. This can be seen clearly in the crackling energy of the painterly surface of *On the River Stour*. Applied with a palette knife, dynamic flickers of color and sparkling flashes of white animate the quiet English scene.

Duncan Phillips considered Constable the founder of modern landscape art and saw him as continuing the landscape tradition of Peter Paul Rubens. Phillips acknowledged his own preference for sketches such as *On the River Stour* to Constable's more finished canvases. He considered it "at least fifty years ahead of its time in its knowledge and full employment of all the emotional capacities of color."

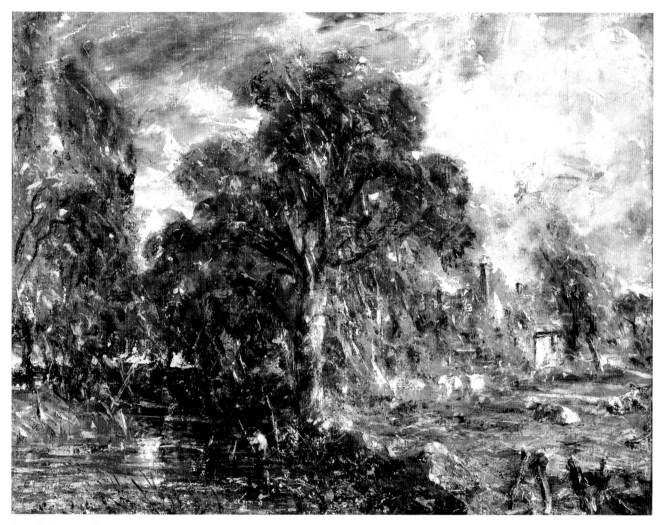

On the River Stour, ca. 1834–37
Oil on canvas
24 x 31 inches (61 x 78.6 cm)
Acquired 1925

Jean-Baptiste-Camille Corot

b. 1796, Paris, d. 1875, Ville-d'Avray, France

Lack of finish, free handling, and spontaneity mark *Civita Castellana* as an outdoor sketch of the kind that Corot made for personal use, as recommended by Pierre-Henri de Valenciennes, two of whose students were Corot's teachers. Making such sketches, according to Valenciennes, taught the artist about nature and served as a reminder of the experience of nature. They were not preliminary studies for particular paintings. Civita Castellana, a medieval fortress town outside Rome, on the road to the north, was a popular place for painting excursions. Corot stayed there for almost a month in 1826 and returned the following year. This little sketch of the countryside around Civita Castellana, with the Sabine Mountains in the distance, superbly demonstrates Corot's ability to capture light and atmosphere.

Corot painted *View from the Farnese Gardens* during his first stay in Italy from 1825 to 1828. At this time, a Roman sojourn was still a necessary stage in an artist's education. While in Italy, Corot worked out of doors. Over the course of seventeen days, he painted three pictures in the Farnese Gardens. He spent the mornings working on The Phillips Collection's painting. The view faces the church of San Sebastiano in Palatino, the building just to the left of the painting's center. At noon, he turned east to continue painting the view of the Colosseum (Louvre, Paris), while later in the afternoon, he shifted to a slightly different position in the Farnese Gardens. From this spot, he would work on the view of the Roman Forum, to the north (Louvre, Paris). The Phillips Collection's painting captures the feeling of a sunlit early morning, cool and clear, before the day turned hot. The light falling in the distance and in the middle ground creates strong shadows. In contrast to Corot's empirical treatment of the light is the generalization of the trees in the foreground, holdovers from the studio conventions of historical landscape painting. Corot's mastery of infinitely subtle tonal values is evident throughout the work.

Corot's third and last trip to Italy occurred in 1843. He spent a month working around Genzano, south of Rome, in June and July. *Genzano* is among the paintings that he made there. In this view, Corot shows Genzano from below, with its buildings set against the sky and slightly obscured by the rocky outcropping in the foreground. Corot brilliantly conveys the bright, flattening light and noontime heat of a summer day in Italy. Unlike *View from the Farnese Gardens* and *Civita Castellana*, the view of *Genzano* includes figures: a peasant boy, his legs tucked under him, on the ground with goats, and a woman hugging the shade as she walks along a dusty road. These consciously picturesque genre elements, particularly the figures of the boy and goat in the foreground, suggest Corot had his eye on the market. Corot's signature red note appears in the woman's scarf. Duncan Phillips noted the looser and evocative quality of *Genzano*: " . . . what we prize above all in such a picture is the caress of the canvas and the song that has been sung about the color and the texture of the soil and the remembered quality of the light and the dark accents of the boy and the goats and the sparkling silvery glimpse of the village of Genzano."

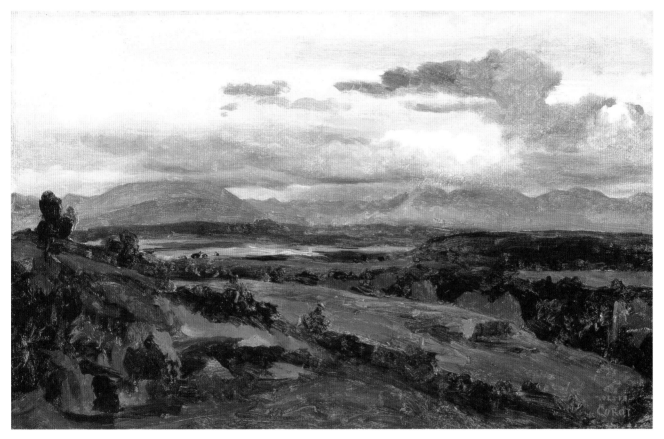

Civita Castellana, 1826 or 1827
Oil on paper
8 ⅞ x 14 inches
(22.6 x 35.6 cm)
Acquired 1946

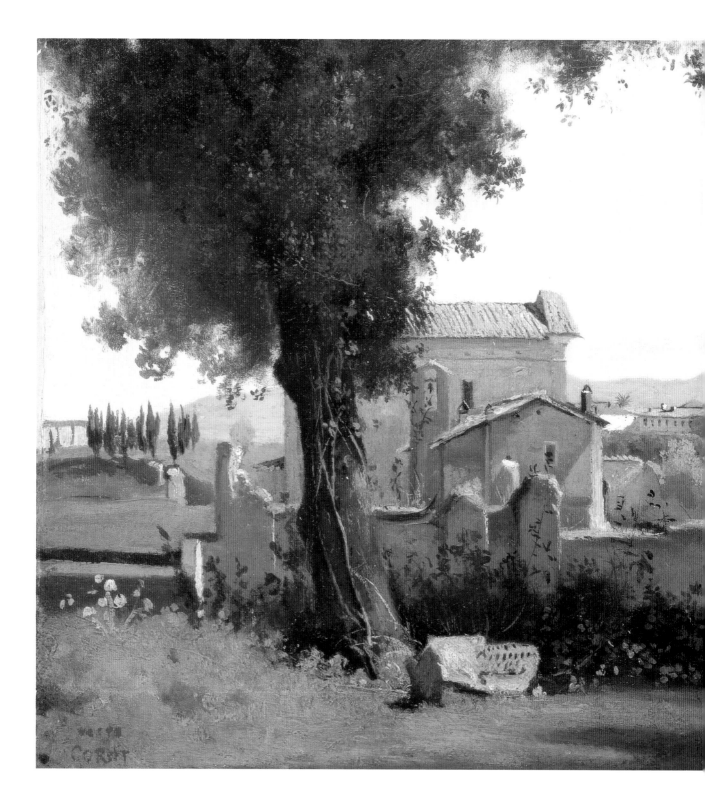

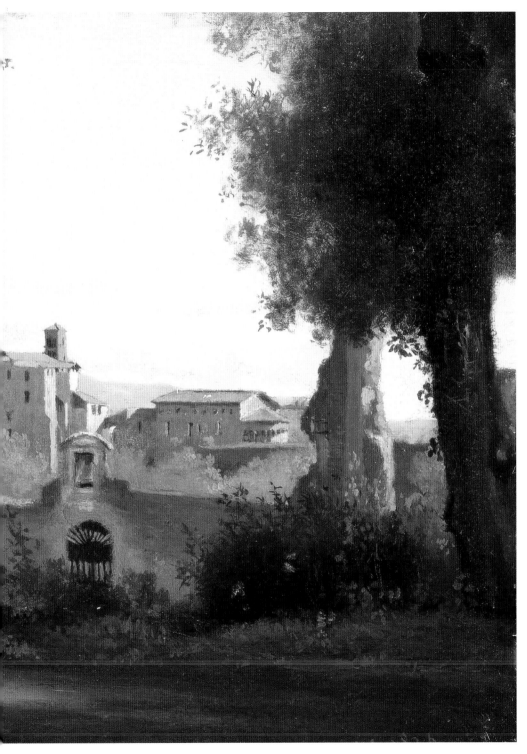

View from the Farnese Gardens, Rome, 1826
Oil on paper, mounted on canvas
9 ⅝ x 15 ¾ inches
(24.5 x 40.1 cm)
Acquired 1942

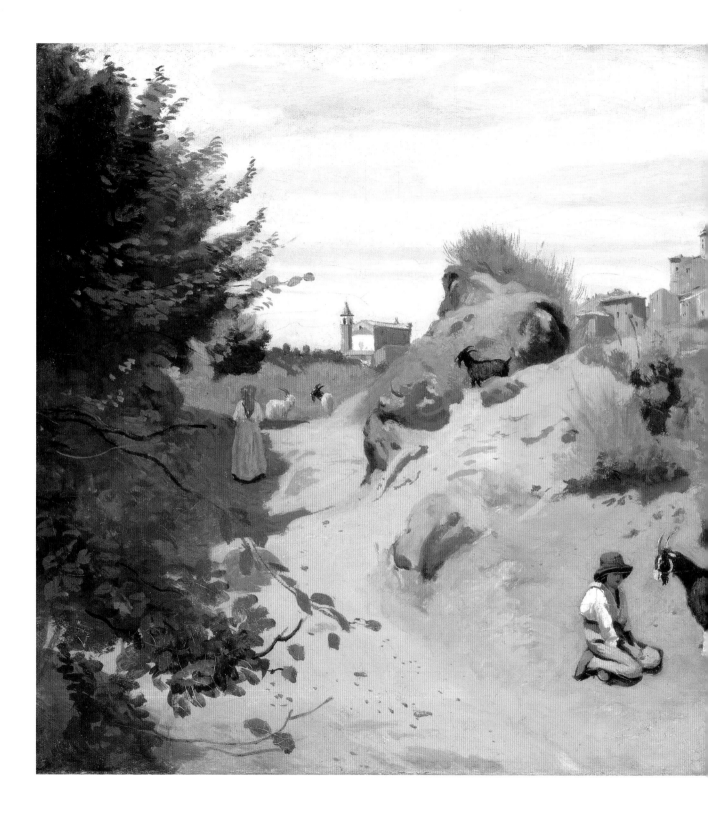

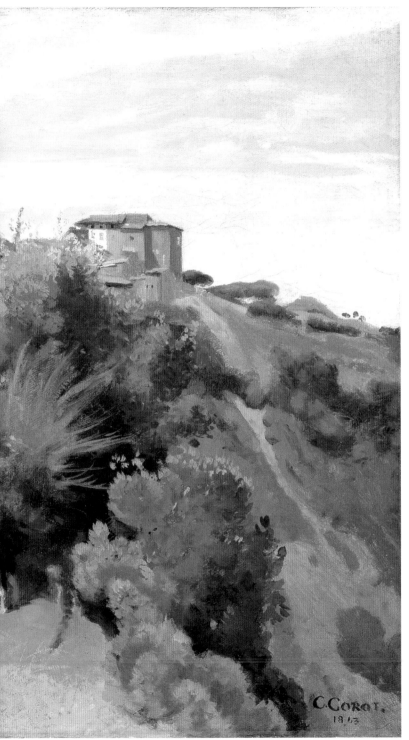

Genzano, 1843
Oil on canvas
14 ⅛ x 22 ½ inches
(35.8 x 57.1 cm)
Acquired 1955

Gustave Courbet

b. 1819, Ornans, Doubs, France,
d. 1877, La Tour de Peilz, Switzerland

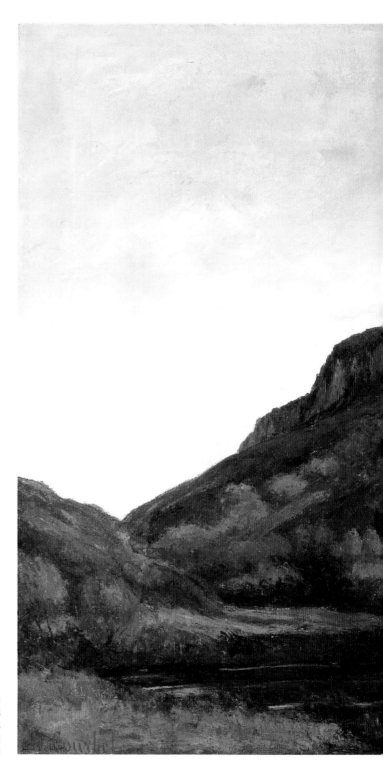

One of the most important painters in the development of modernism, Courbet closely linked his anti-idealist approach to art with his anticlerical and political beliefs. Critics considered his unconventional early works— monumental paintings of peasants and laborers —ugly and offensive. After 1855, when Courbet organized his own exhibition, the Pavilion of Realism, following rejection at the Paris World Exposition of the same year, he concentrated on landscapes and hunting scenes, for which he won official recognition. Ever political, Courbet publicly turned down the cross of the Légion d'honneur in 1870. His involvement in the Paris Commune the following year cost him six months in jail for participation in the destruction of the Vendôme column. Courbet spent the last four years of his life in Switzerland.

The artist's independent approach to the world did not accommodate the traditional academic hierarchy of subjects. It is clear that landscape, and particularly that of Franche-Comté in eastern France where he grew up, held a primal, almost sacred importance for him. *Rocks at Mouthier* depicts a landscape in the vicinity of Ornans, Courbet's birthplace. The setting has been identified as the rocks of Hautepierre, a massive outcropping overhanging Mouthier-Haute-Pierre, depicted in many of Courbet's works. Its importance as a landmark to Courbet is suggested by the fact that the

Rocks at Mouthier, ca. 1855
Oil on canvas
29 ³/₄ x 46 inches
(75.5 x 116.8 cm)
Acquired 1925

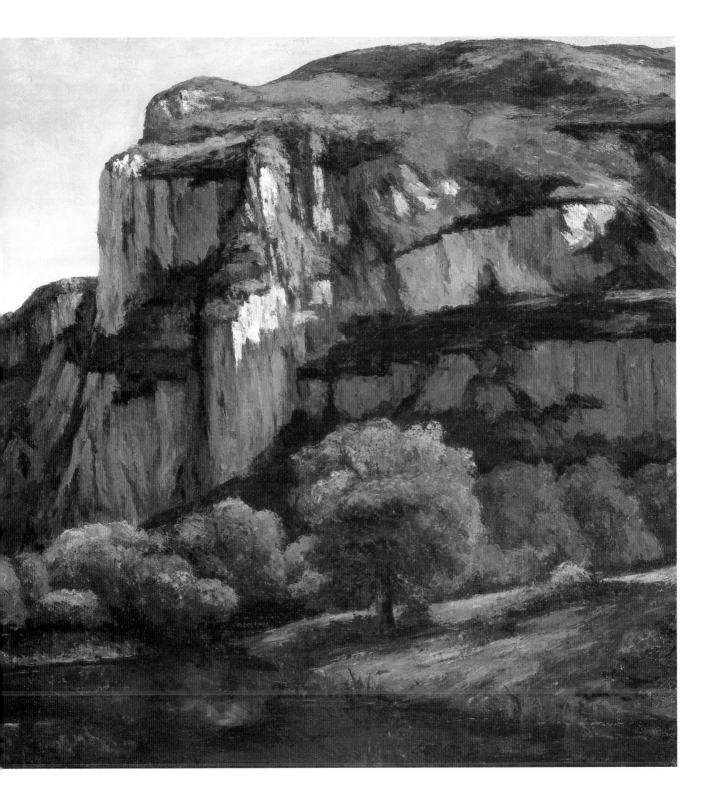

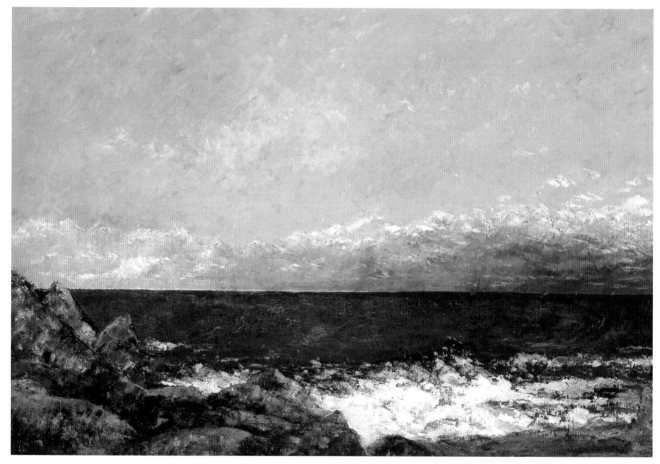

The Mediterranean, 1857
Oil on canvas
23 ¼ x 33 ½ inches
(59 x 85.1 cm)
Acquired 1924

outcropping is the subject of the painting on the easel in Courbet's most famous painting and manifesto of 1854–55, *The Painter's Studio* (Musée d'Orsay, Paris).

In The Phillips Collection's painting, the steep escarpments and limestone cliffs of Hautepierre dominate the canvas, filling most of it on the right, pushing up to the top, and leaving room for just a sliver of blue sky above. On the left, the cliffs fall away, revealing a big sky that fills the upper left quadrant of the painting. In the foreground the dark waters of a stream reflect the deep greens of lushly painted trees and vegetation. To the left, a trail leads through the valley before vanishing at the top of a hill. Patches of sunshine illuminate some of the vertical rock faces. In other areas entrances to dark caves are visible. Shadows on the undulating turf that covers the rock formation at the upper-right quadrant of the canvas tell of passing clouds, and where the horizontal turf layer meets the planes of the rock turrets, Courbet shows how thin that stratum is. Evidence suggests Courbet took an interest in the ancient geology of his native region. What makes this painting so compelling is the combination of precise scientific observation with a bravura application of paint, visible in the treatment of the eroded rock face. Slashing away with his palette knife, Courbet seems almost to have quarried the rock out of paint.

Courbet probably painted *The Mediterranean* during his second visit to the south coast of France, where he was the guest of a wealthy patron. An intense color study, the painting is also a mesmerizing composition. The subject is simple: light, sky, clouds, sea, foam, and rocks. Far away, almost invisible, some tiny sailboats appear on the right side of the canvas near the hard horizon line, which separates the bank of cloud from the dark green zone of the sea a little more than a third of the way up from the bottom of the canvas. This exerts the same irresistible focal pull one feels at a beach and divides the world and canvas into two rectangles, sky above, sea and rocks below. Within the two rectangles, Courbet develops variations in color and shapes along the axis of the horizon, the composition of the upper rectangle of the sky echoing in color and shape that of the lower rectangle of the sea and shore. In *The Mediterranean*, as in *Rocks at Mouthier*, the paint is applied with both brush and palette knife.

Duncan Phillips bought both these works early in his career as a collector. He recognized the vigor and independence of Courbet's elemental and nonliterary vision, and regarded him as a kind of Walt Whitman of painting.

Honoré Daumier

b. 1808, Marseilles, d. 1879, Valmondois, France

Daumier is best known for his cartoons showing the plight of the poor and his political caricatures of French society under Louis-Philippe. A painter of considerable power, he was a favorite of Duncan Phillips who relished Daumier's ability to convey the drama of everyday life in a universal way. For this, as well as for his monumental forms, Phillips considered Daumier the peer of Michelangelo.

The Uprising depicts a moment of revolutionary uproar in the streets and may have been inspired by the revolution of 1848 and the overthrow of Louis-Philippe's July Monarchy. Some scholars believe, however, on stylistic grounds, that Daumier painted it in the second half of the 1850s. Critics generally agree that a later hand retouched parts of the painting and that Daumier left the painting in a more sketchy form than the extant work. Phillips felt that, in its essence, the work revealed Daumier, in spite of later additions. He said that "an unfinished masterpiece cannot be left out nor underrated if the heart, the mind and the hand of a great artist at his best have been revealed in the essential part of the picture which carries the emotional expression." Phillips made it clear that *The Uprising* was his favorite among Daumier's paintings and referred to it at times as "the greatest picture in the Collection."

Three Lawyers takes up a theme that Daumier treated in countless works on paper. Daumier himself had experienced French justice. He was charged with sedition for lampooning Louis-Philippe and served six months in jail, after which government censorship forced him to focus on bourgeois society and manners.

He clearly enjoyed mocking the legal profession and obviously felt that the deck was always stacked against society's poor, lowly, and defenseless. No matter what the outcome for the little man, the lawyers in Daumier's images always do fine. Whilst in the courtroom they attack each other with obligatory theatricality, outside there is unity and collusion. Here they are, self-congratulatory, puffed up with self-importance, exchanging clever quips. In the background at the left, a weeping woman, unnoticed by the lawyers, is a reminder of the human toll of legal action. Phillips noted the beautiful and colorful effects that Daumier extracted from a palette of blacks and whites, comparing him to Velázquez, Gerard ter Borch, and Rembrandt.

The Strong Man shows a *parade*, a little sideshow that took place outside a tent or a theater to promote the main spectacle inside, behind the curtain being pulled aside. The frenzied barker, possibly wearing a pierrot costume, his arms and skullcap garishly lit, yells and gestures to show off the strong man who stands by impassively, his big arms folded across his chest. The figures are shown half-length as though seen over the heads of a watching crowd. The legs in the upper left, on a poster, seem to complete the picture of the strong man in an amusing way. This type of *parade* had lost popularity by the time Daumier depicted it in this painting, suggesting the work may be the artist's oblique comment on Louis Napoleon's propaganda machine.

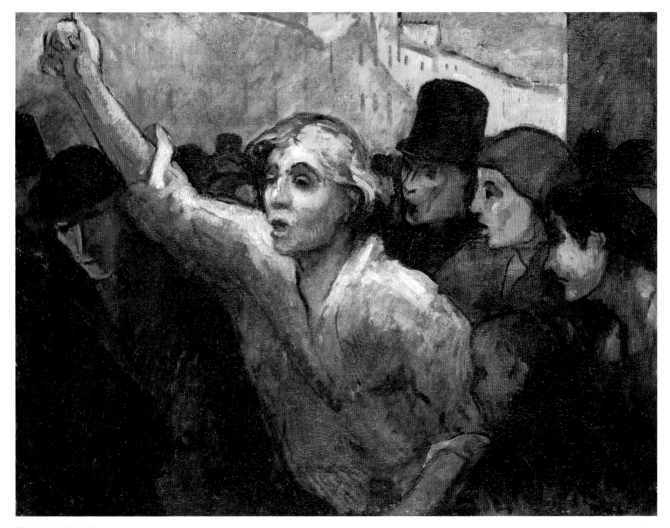

The Uprising, 1848 or later
Oil on canvas
34 ¹/₂ x 44 ¹/₂ inches
(87.6 x 113 cm)
Acquired 1925

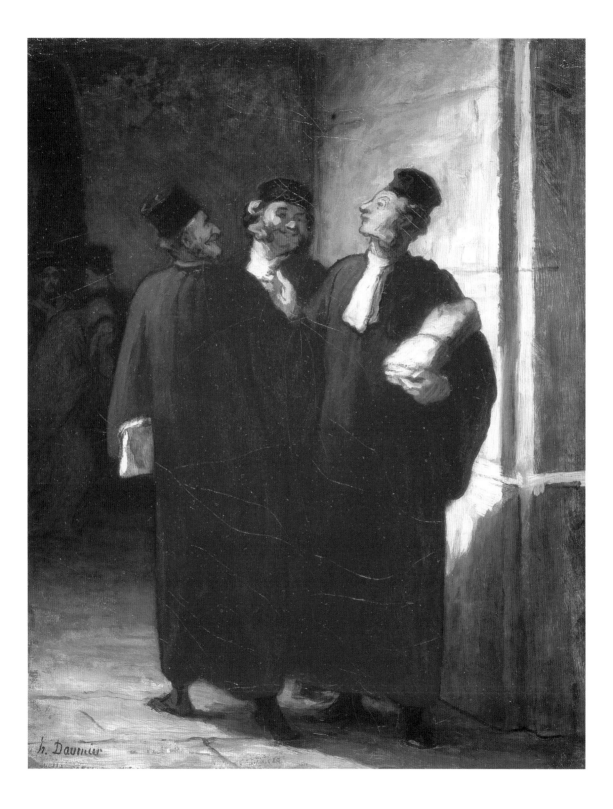

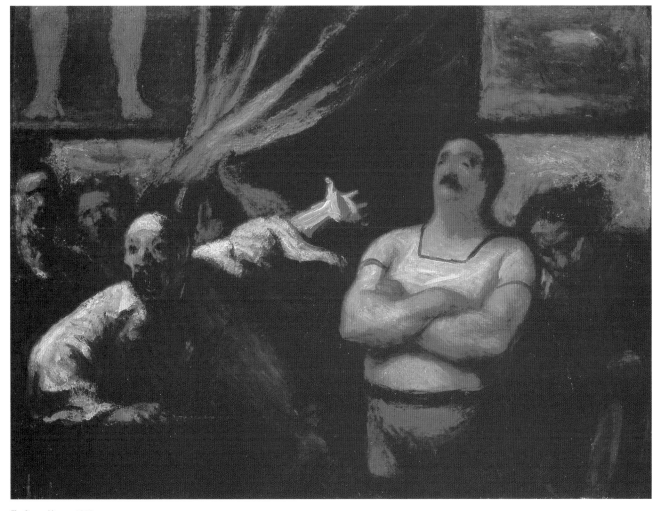

The Strong Man, ca. 1865
Oil on wood panel
10 ⁵⁄₈ x 13 ⁷⁄₈ inches
(27 x 35.2 cm)
Acquired 1928

Three Lawyers, 1855–57
Oil on canvas
16 x 12 ³⁄₄ inches
(40.7 x 32.4 cm)
Acquired 1920

Hilaire-Germain-Edgar Degas

b. 1834, Paris, d. 1917, Paris

Degas was predominantly a figure painter and a consummate draftsman. An acute observer of modern life, Degas was a driving force behind the organization of the first impressionist exhibition in 1874 and participated in six of the seven impressionist exhibitions that followed. However, he disliked the label impressionist. Although his career was a long exploration of modern life and new techniques, he had little interest in landscape painting, unlike the other impressionists, and was scornful of *plein-air* painting. Degas was a passionate and discerning collector who bought numerous works by other artists.

Melancholy, Degas's portrait of an unknown woman, dates from early in his career and exemplifies the artist's considerable psychological powers as a portraitist, as well as his understanding of the revelatory nature of gesture. He shows his subject, dressed in red with a white collar, leaning forward out of a red-brown upholstered chair, her arms crossed and hugged to her body, her face in three-quarters profile, resting against the back of the chair. The sitter's pose and the way the scene is lit from below suggest that she is staring into a fire. Although it is questionable whether the title of the work dates from Degas's lifetime, the expression on his sitter's face implies introspection perhaps brought on by staring into the flames when feeling miserably cold and in search of warmth. Fragmentary and sketch-like qualities (the fire, unseen but implied, the indistinct background with its suggestion of a screen, the unfinished look of the paint surface on the back of the chair) and the Japanese

reference of its asymmetrical, diagonal composition contribute to the power of this tiny but concentrated painting.

The private world of women was one of Degas's favorite subjects. His oeuvre is full of images of women grooming themselves. *Women Combing Their Hair* is one of his earliest versions of the subject. It shows the same model in a series of three poses, wearing a simple ankle-length white shift, with her long auburn hair loose as she combs it. Degas seems to have been fascinated as much by hair as by the various poses that grooming it could elicit. Here he shows it on the standing figure as a sheet of shimmering auburn falling to one side of the model's face and hiding it. The figure in the center has the hair flipped over her head. Degas shows her from behind, sitting in a folding chair. He suggests the tension in her spine as she holds her arms up to grasp her hair with her left hand, while she combs the underside of it with her right. On the far right, in a subtle reversal of the pose of the central figure's left arm, the model combs a big hank of hair with her right hand. Presumably her unseen left hand holds the hair near the nape of her neck and provides the resistance to the action of the comb to prevent her scalp from being tugged. The balanced asymmetry of the composition offsets the independent existence of the individual figures, and the nature of the

Women Combing Their Hair, ca. 1875–76
Oil on paper, mounted on canvas
12 ³⁄₄ x 18 ¹⁄₈ inches
(32.4 x 46.2 cm)
Acquired 1940

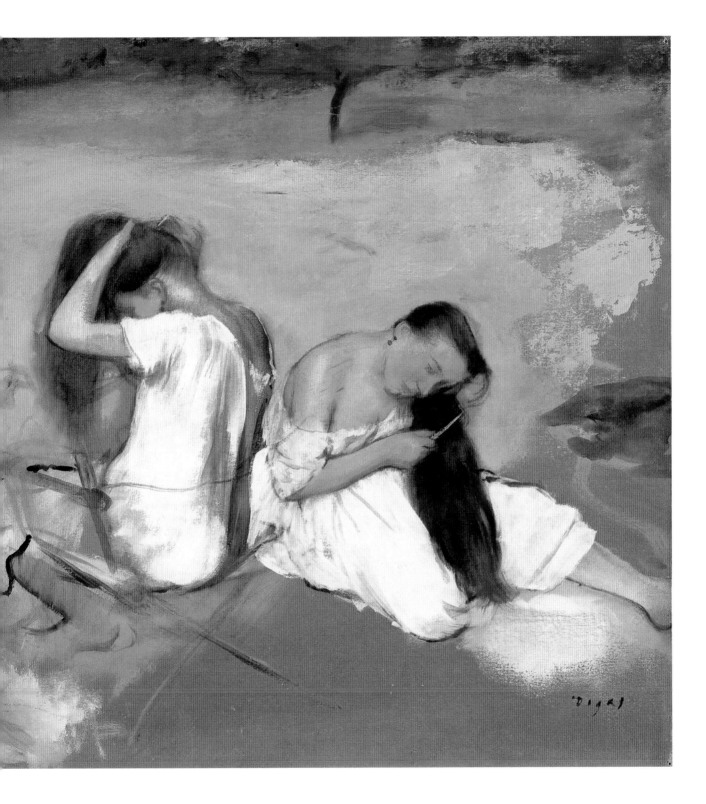

activity depicted accounts for their apparent isolation. The unfinished drawing of the figures and folding chair, and the indeterminate landscape setting, a beach by a river, suggest that the painting probably started out as a sketch that Degas came to view as a finished work.

Degas found in ballet the ideal modern idiom for his most important subject, the human body. Ballet, itself an art of the body, with its stress on line, was a perfect subject for an artist with Degas's preoccupation with drawing. Degas drew and redrew the dancers' poses and then, choreographing his own paintings, combined the poses into paintings. He painted ballet subjects throughout his career, as often depicting dancers exhausted and slumped in awkward stances as practicing within the prosaic settings of rehearsal halls and waiting rooms. *Dancers at the Bar*, which dates from late in the artist's career, was in his studio at his death. It is one of the latest representations by Degas of the motif of a dancer with her leg up on a practice bar, a subject that appeared as early as the mid-1870s. Like many of Degas's treatments of ballet, *Dancers at the Bar* captures the inherent formal strangeness of its poses, as the individual dancers fuse into a group. In this painting, the two dancers are seen from behind as conjoined twins, their blue dresses forming one shared skirt, as facing away from one another they stretch opposite legs on the bar. The straining muscles visible in the back of the red-haired dancer and the strong diagonal thrust of the composition, seen in the rising floor and the pointing left foot of the dancer on the left, counter the apparent stillness of the poses. A large painting, its size is matched by the intensity of its strong complementary oranges and blues, its freedom of execution, and the monumentality of its bold composition in which spatial concerns are subordinated entirely to those of form. *Dancers at the Bar* is an example of how towards the end of his career, Degas's use of medium and color became increasingly expressive.

Degas is one of the artists whose work Duncan Phillips collected in depth. Phillips recognized the impressionist qualities of Degas's works, but he also saw and admired those that distinguished Degas from the group: a stress on line which Phillips likened to that of Holbein and Botticelli, and a use of formal compositions which Phillips thought echoed Japanese works. Phillips was also particularly sensitive to Degas's colorful and expressive style.

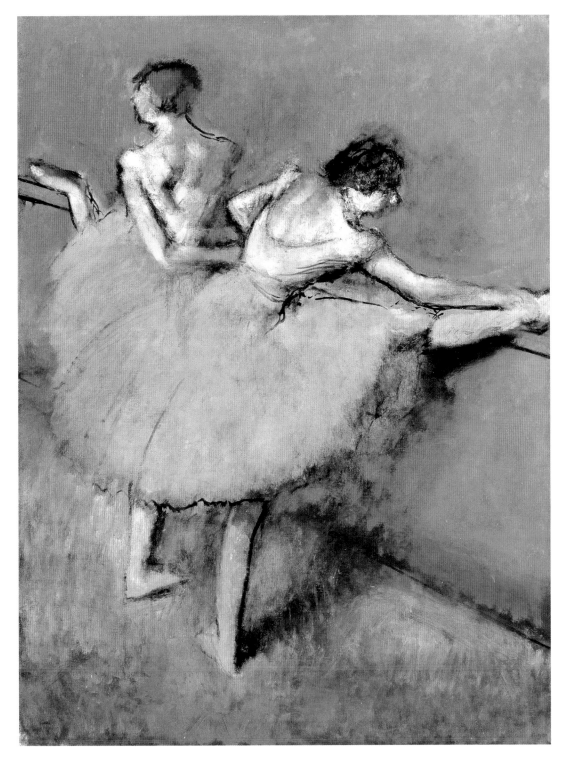

Dancers at the Bar, ca. 1900
Oil on canvas
51 ¼ x 38 ½ inches
(130.1 x 97.7 cm)
Acquired 1944

Ferdinand-Victor-Eugène Delacroix

b. 1798, Charenton-Saint-Maurice, France, d. 1863, Paris

Delacroix heard the legendary Italian violinist and composer Nicolò Paganini play at the Paris Opera on March 9, 1831, and painted the small, full-length portrait of the virtuoso a short time thereafter. Contemporary accounts, confirmed by Delacroix's painting, make clear that Paganini's appearance was strange, if not repellent. He was tall and thin, cadaverously pale with missing teeth, and had shoulder-length black hair. In performance, however, he charmed, and his presence was electrifying. It was noted that he played with his right foot thrust forward beating time, while his garments flapped around his skinny frame. Delacroix's portrait of Paganini, the only one he painted of a contemporary celebrity outside his circle, shows the violinist in concert and is executed with an energy and brilliance that matches the playing of its subject. The black-clad figure of Paganini is barely distinguished from the dark background, as he stands with his weight on his left foot, his right leg forward and bent at the knee. Light falls only on his face, with closed eyes, his all-important hands, and his shirtfront. The line of the bow shines against the violin, itself barely discernible against the surrounding darkness. Delacroix, who was a great music lover and was himself a violinist, wrote in his journal his thoughts about the relationship between music and painting, comparing painted sketches and musical improvisations, and likened the act of painting to playing the violin. His portrait of the virtuoso, rough and sketch-like in its gestural brushstrokes and finish, is a perfect painterly equivalent of Paganini's performance style and is a distillation of the romantic concept of genius.

In 1832 Delacroix traveled with a diplomatic mission to the Sultan of Morocco. He returned from North Africa with volumes of notes and sketchbooks. These, and especially his memories, supplied him with motifs for the rest of his career. The brilliantly colored painting, *Horses Coming out of the Sea*, one of the works that resulted more than a quarter century later, combines an oriental subject with two of Delacroix's favorite motifs: the sea, which is featured in many of his late works, and the horse. Delacroix responded to the power, grace, speed, and ferocity of wild animals and to the same qualities in horses. The horses he preferred to paint were Arabians, to this day widely considered the world's most beautiful breed. With their distinctive dished profile, large, wide-set eyes, broad forehead,

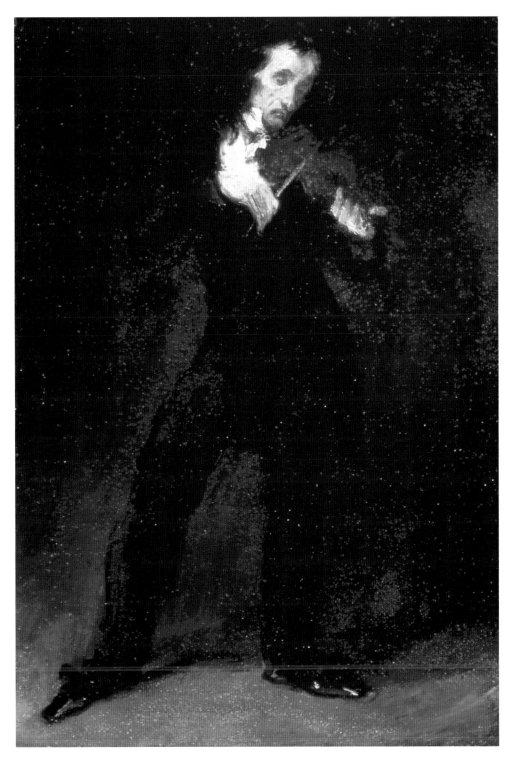

Paganini, 1831
Oil on cardboard, on wood panel
17 ⁵/₈ x 11 ⁷/₈ inches
(44.7 x 30.1 cm)
Acquired 1922

small, curved ears, large nostrils, and great arched necks, they were particularly suitable subjects for Delacroix's dynamic and baroque paintings. Delacroix captured their energy and power, invariably showing them, as here, nervous, excitable, and in motion, with wild manes and tails. Towards the end of his career, Delacroix painted fewer and fewer history paintings, and *Horses Coming out of the Sea* makes no obvious literary or historical allusion. It is also interestingly lacking in picturesque detail beyond the turban of the rider and the tiny figure of an Arab horseman in the background, on the far right of the canvas. Making a telling distinction between accuracy and truth, Delacroix noted in his journal that only after he had forgotten the details did he get full value out of his North African experience.

Duncan Phillips bought three paintings by Delacroix and a charcoal-and-watercolor drawing. Early on as a collector, Phillips admired Delacroix for his liberating effect on French art and for his expressive drawing and emotion-laden color, but objected to his dependence on literary sources. For this reason Phillips, who called the *Paganini* a "tiny soul-portrait," considered it not to be a typical work by Delacroix. Twenty years later, Phillips recognized in *Horses Coming out of the Sea* "a rare combination of the classic and romantic . . . in one integrated and classic design."

Horses Coming out of the Sea, 1860
Oil on canvas
20 ¼ x 24 ¼ inches (51.4 x 61.5 cm)
Acquired 1945

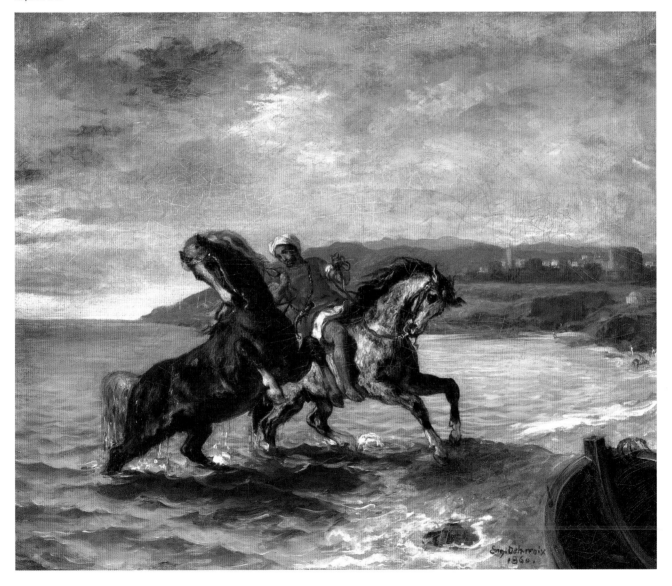

Raoul Dufy

b. 1877, Le Havre, d. 1953, Forcalquier (Basses-Alpes), France

The Opera, Paris, early 1930s
Gouache on paper
19 ³/₄ x 25 ¹/₄ inches
(50.2 x 64 cm)
Acquired 1939

Dufy's subject matter was pleasure. He painted elegant people having a good time in public, especially at racetracks like Epsom and Ascot, or watching regattas at Deauville, or cavorting on the French Riviera or in a Parisian park. Dufy painted wittily and made it look easy, as Duncan Phillips pointed out, carefully concealing the discipline that underlies his work. Dufy started out as an impressionist but was powerfully affected in 1905 by the revolutionary color and subjectivity of Henri Matisse's painting, *Luxe, calme et volupté* (Musée d'Orsay, Paris). Dufy, thereafter, gave up on objective appearances, working for a time in a fauvist vein before finding his signature colorful, exuberant, and calligraphic style. In the 1920s Dufy's trips to Morocco, Italy, Sicily, and the south of France exposed him to Mediterranean light and led him to brighten his work and start painting in watercolors. Dufy worked widely—and brilliantly—in the decorative arts, because he needed the money and, in any case, he made no distinction between fine and decorative arts. He designed textiles for Paul Poiret, the leading couturier of the day, whose tubular fashions provided perfect unarticulated fields for patterns. Dufy also created stage designs, prints, book illustrations, tapestry cartoons, and ceramics.

Music mattered to Dufy who grew up in a musical family. Late in his career, he worked on a series of paintings of orchestras. *The Opera, Paris* shows the interior of the theater as a vast transparent space of red and gold, filled with light, its ornate decorations shown as a loopy, rococo confection of arabesques. The bay at the center of the composition suggests a musical

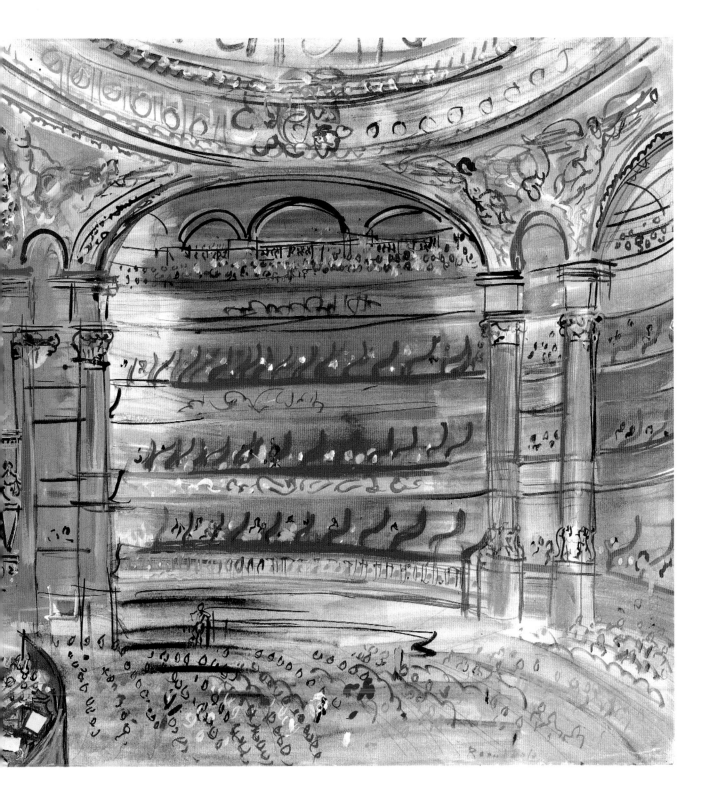

score, the emphatic lines of the balconies forming a staff framed by the double bars of the columns. The audience filling its tiers and stalls assumes the form of a schematic notation of squiggles in red, black, and white. In the pit, the string section dominates through the forceful lines of its bows. Dufy's decorative lines are independent of color. Executed with a dynamic, sure hand, they convey the atmosphere of excitement in the house as the orchestra tunes up.

Dufy made several paintings on the theme of the artist's studio, starting in 1909. The studio in The Phillips Collection's painting was located in the impasse de Guelma in Montmartre. Dufy used it from 1911 until his death. *The Artist's Studio* provides information about the place where Dufy painted and is, at the same time, a sort of self-portrait and summary of his work. Around the studio, which actually was cerulean blue, and in the room adjoining it on the left, are paintings by Dufy, some of them identifiable. On the wall at the left is a floral textile similar to those he designed for Bianchini-Férier, an important manufacturer of luxurious silks used by Paul Poiret. Beyond it are ship models from Dufy's collection (he grew up by the sea and schooners appear in many of his marine subjects) and below them, on the left, his *Great Bather*. The painting on the wall at the right is one of Dufy's homages to Claude Lorrain, below it, a picture of boaters on the Marne. The reclining nude on the easel recalls many of Dufy's Amphitrites and bathers, as well as his debt to rococo painting. The palette and easel in the foreground are bare: *The Artist's Studio* is the painting and the colors are on it—Dufy's favorites, blue and pink with orange, accents of green and red tied together with luminous white, and the indispensable, ever-present black line. The window, outlined in white, echoes the shape of the easel. Through it and the transparent membrane of the wall, interior and exterior merge as Dufy incorporates the architecture of the street into the studio and the physical world into his canvas. The two zones of the painting, the plain blue space and the patterned pink space, are shorthand, respectively, for Dufy's transparent color and his endlessly inventive and amusing line.

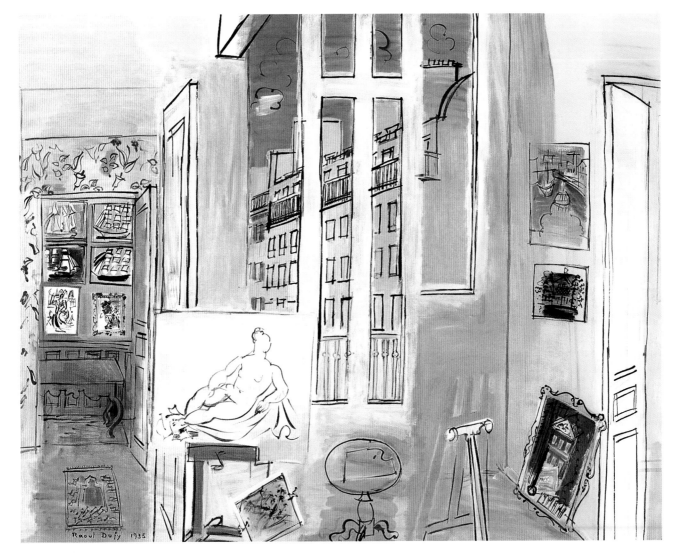

The Artist's Studio, 1935
Oil on canvas
47 x 58 ⁷/₈ inches
(119.4 x 149.6 cm)
Acquired 1944

Paul Gauguin

b. 1848, Paris, d. 1903, Atuona, Marquesas Islands

Gauguin started painting in his spare time at the age of twenty-three and without any formal training. Only in 1883, aged thirty-five, did he abandon his conventional life as a wealthy stockbroker and begin to paint full-time. In 1886, five years before he set sail for Tahiti, Gauguin discovered that in Brittany he could satisfy his need for powerful and resonant symbolism. He liked Brittany, he said, because he found it savage and primitive. The flat sound of his wooden clogs on Breton cobblestones was the note he said he wished to strike in his paintings. In Brittany, with other artists, Gauguin developed synthetism, a version of the symbolist style, combining aestheticism, subjectivity, and realism. In practice, it was an approach to painting that was antinaturalistic, both by virtue of its recognition that a painting is a flat surface and its stress on expressive drawing and colors rather than on accuracy and local color. These ideas are manifested in the strong, rich colors, intricate and decorative patterns, and spatial complexity of *The Ham*, which Gauguin probably painted in Le Pouldu, a Breton village.

Gauguin painted relatively few still lifes and *The Ham* is his only painting of a slab of meat. Probably the painting was inspired by Edouard Manet's *Ham* (The Burrell Collection, Glasgow), which Gauguin is likely to have seen in January or February 1889 in Edgar Degas's Parisian apartment. Manet's ham sits plump, cooked, elegant, and very still on a dish placed on a counter in front of a chic, decidedly bourgeois wallpaper background, its pattern echoing the veins of fat in the meat. Gauguin's ham, perhaps smoked, looking raw, seems to curl on a dish on the surface of a round bistro table, the curlicues of fat in the ham and the roundness of the onions with their decoratively twisted shoots echoing the delicate metal supports of the table. Gauguin's ham, glowing red and orange against a backdrop of intense, exotically orange wallpaper, is uncanny and animated. Gauguin has painted it as though reading faces into the patterns of its fat and making a folk carving of the bone's gnarled end at the left. "Do not paint too much after nature," said Gauguin. "Art is an abstraction. Extract it from nature while dreaming in front of it and think more of the creation which will be the result." Another source of inspiration for this still life was Paul Cézanne, with whom Gauguin painted in 1881 and whose work he collected. Cézanne's influence can be seen in the outlining of the onions and in their highlights, as well as in the tonal variations of the background made by strokes of changing colors, like shot silk. It can also be seen in the plasticity of the forms that here contradict the flatness of the background and in the way the tabletop tilts upward and is only restrained visually by the vertical patterns of the wallpaper.

Phillips was drawn to Gauguin's vibrant colors, recognizing the originality of his work and its importance for subsequent painting. Although Phillips regarded Gauguin as a romantic idealist in the manner of Jean-Jacques Rousseau, he expressed reservations about Gauguin's primitivism. Perhaps, as a result, Phillips deaccessioned one of the artist's Tahitian scenes before buying *The Ham*.

The Ham, 1889
Oil on canvas
19 ³/₄ x 22 ³/₄ inches
(50.2 x 57.8 cm)
Acquired 1951

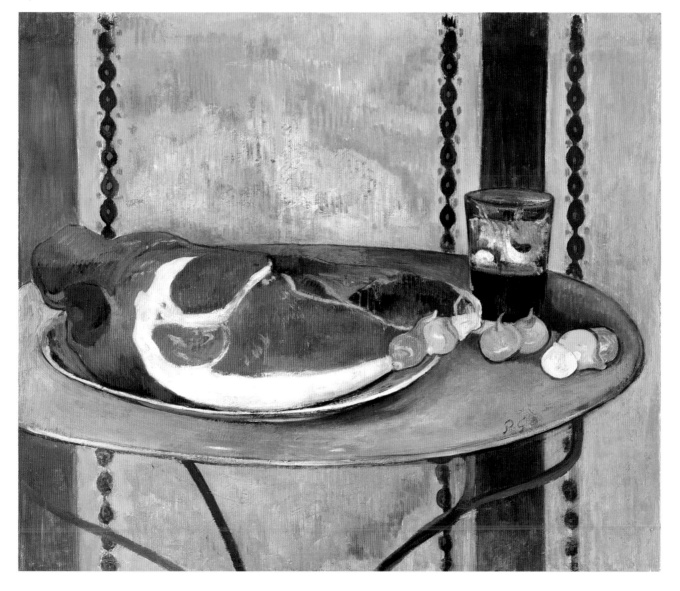

Alberto Giacometti

b. 1901, Borgonovo, Switzerland, d. 1966, Chur, Switzerland

Giacometti's intensely watchful *Monumental Head*, a portrait of his brother Diego, was to be part of a large sculptural group commissioned for the public plaza of Gordon Bunshaft's Chase Manhattan Bank in New York. The project consisted of four standing female figures, two striding males, and a massive gazing head to represent urban and artistic culture. It was also intended to survey the activities of the other figures in the plaza, both animate and inanimate. Giacometti eventually dropped the project but completed the head. The long, narrow head and neck of *Monumental Head*, with its hypnotic gaze, reflect Giacometti's long-standing interest in non-Western and ancient art, as well as his view that "the truer a work is the more stylized it is." The model for his totemic head was the colossal bust of the fourth-century Roman emperor, Constantine the Great (Palazzo dei Conservatori, Rome).

The Roman work's dominating height, over eight feet, and the intensity of its unwavering gaze assert Constantine's imperial power. A sketch of the colossal head that Giacometti made in Italy between 1959 and 1960 emphasizes its large eyes, which prefigure the eyes of his *Monumental Head*. Gaze was a motif in Giacometti's work throughout his career. He observed that too much precision in the representation of the eyes resulted in the destruction of the gaze. Marjorie Phillips, who was perhaps more interested in sculpture than her husband, organized an exhibition of Giacometti's work in 1963. The Phillipses kept *Monumental Head* permanently on view and considered Giacometti to be "one of the most distinguished contemporary sculptors" and described his heads as "monumental tributes to the average man."

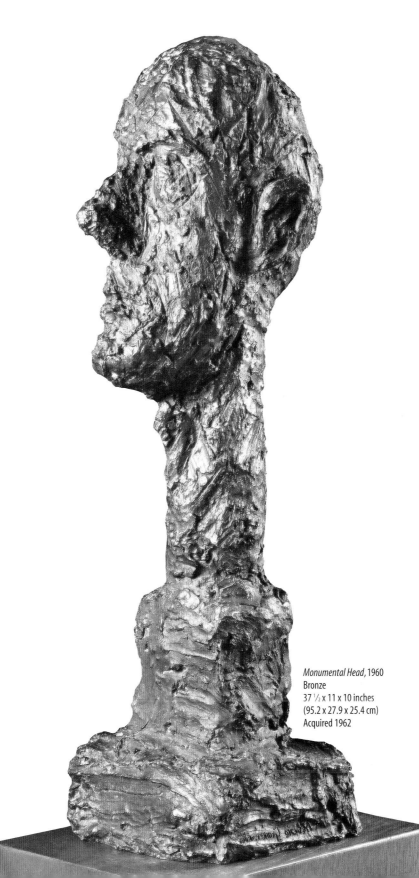

Monumental Head, 1960
Bronze
37 ½ x 11 x 10 inches
(95.2 x 27.9 x 25.4 cm)
Acquired 1962

Francisco José de Goya

b. 1746, Fuendetodos, Spain, d. 1828, Bordeaux

In a powerful image of intense communion with God, Goya presents Peter as a half-length figure, his face turned up towards heaven, his lips parted as though speaking, and his eyes full of tears. The artist shows him kneeling beside a rock, a reference to the name Christ gave the apostle, "thou art Peter, and upon this rock I will build my church . . ." (Matthew 16: 18). On the rock lies the saint's chief attribute, a pair of keys. Jesus made Peter the guardian of the Gate of Heaven, saying "and I will give unto thee the keys of the kingdom of heaven: and whatsoever thou shalt bind on earth shall be bound in heaven . . ." (Matthew 16: 19). Goya, like El Greco (see p. 82), gives the saint his traditional garb, a blue tunic and a yellow cloak. In both versions the saint is shown, according to custom, as an old man with white hair and beard. Where El Greco provides a physical and theological setting for the image of the penitent Peter, Goya's simple triangular composition consists of a powerful, bulky figure in a dark setting. The figure's foreshortening suggests Goya designed the painting to be seen from below. It has a pendant, a picture of Saint Paul (private collection, United States), but the circumstances of their creation are unknown. On stylistic grounds, The Phillips Collection's painting is dated to the period just before Goya departed for Bordeaux.

The subject of this painting (and the one by El Greco) is the penitence of Peter following his denial of Christ. According to the Gospels (Matthew 26: 69–75), after the arrest of Christ and after his interrogation at the house of the High Priest Caiaphas, Peter repeatedly denied that he was a follower of Christ. Following his third denial, a cock crowed, and Peter realized that one of Christ's prophecies had been fulfilled. The account in Matthew says that Peter then went outside and wept bitterly.

Goya, whose early output consisted largely of cartoons for the Royal Tapestry Factory of Santa Bárbara, became Painter to the King in 1786 and Court Painter in 1789. His achievement extends far beyond his official work, encompassing satirical prints and private works. His long career spanned tremendous political upheavals throughout Europe and many of these events are reflected in his works. In 1824, using the pretext of ill health to escape the repressive absolutism of Ferdinand VII, the painter went into voluntary exile in Bordeaux, where he remained and worked for the rest of his life.

Goya's influence on nineteenth-century artists was profound. Duncan Phillips considered him "the stepping stone between the Old Masters and the great Moderns" and saw him as anticipating Cézanne's "modeling by modulations, also his weight and grandeur." The Phillips Collection may be unique among museums of modern art in having two paintings of the Repentant St. Peter, the one by Goya, the other by El Greco. Given their significance as protomoderns in Phillips's version of modern art history, it is perhaps fitting that both are represented by the figure of Peter, Goya's "grubby, earth-bound [saint] . . . solid as a rock" and El Greco's "disembodied spirit," as the collector described them.

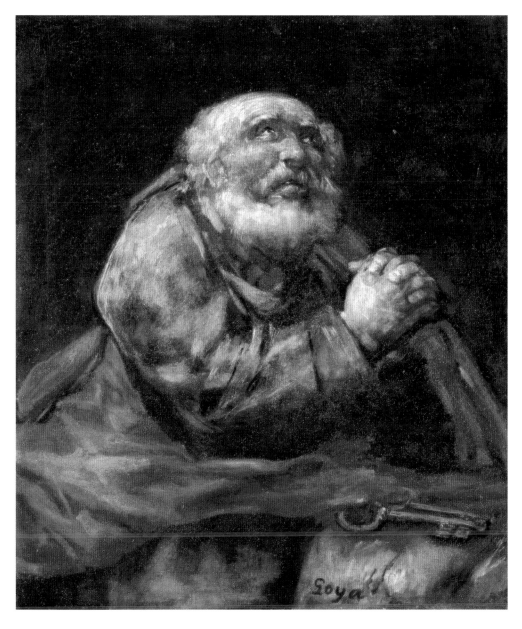

The Repentant St. Peter, ca. 1820–24
Oil on canvas
28 ³/₄ x 25 ¹/₄ inches
(73 x 64.2 cm)
Acquired 1936

El Greco (Domenikos Theotokopoulos)

b. 1541, Candia (Iráklion), Crete, d. 1614, Toledo, Spain

In this image of the penitent Peter, the saint's every gesture expresses his sorrow. He is shown as a weeping, half-length figure in front of a cave with ivy, symbol of eternal life, growing around it. El Greco shows the saint with his traditional attributes: white hair and beard, a pair of keys at his waist, and clothing consisting of a blue tunic and a yellow mantle. The saint's tear-filled eyes look up towards heaven. His parted lips turn downwards as though he is wailing. His hands are clenched together over his heart in a gesture of contrition and supplication referring to the passage in the Gospel of Matthew that recounts Peter's denial of Christ and his subsequent repentance, the moment El Greco shows here.

Possibly designed as an image for personal devotion, the work associates two events, Peter's penitence and Christ's Resurrection. To Peter's side, and in the distance, an angel radiant in chalky white stands by Christ's empty tomb, which is unseen here but present in other versions of this composition. In the middle ground stands Mary Magdalene with her ointment jar. She was one of the Marys who went to Christ's tomb and found it empty after the Resurrection. The presence of Mary Magdalene, a former prostitute whom Christ redeemed and who, according to Christian tradition, spent the remainder of her life alone, atoning for her sins, underscores the theme of repentance as a path to salvation.

El Greco, who started painting in the traditional Byzantine manner, adopted a Western style, becoming a colorist in the Venetian tradition and a highly original artist. The distinctive dynamism and elegance of his style, seen in his characteristic elongation of the human figure and his flickering highlights, suggest the influence of Italian mannerists as well as Byzantine icons. The Phillips Collection's painting is one of several pictures that El Greco painted of Saint Peter in tears. El Greco scholars place it on stylistic grounds late in the painter's career.

El Greco learned to paint in Candia (Iráklion), Crete, before moving to Venice by August 1568. There, he came under the influence of Jacopo Bassano, Tintoretto, Titian, and Veronese. In 1570 El Greco was in Rome and seven years later went to Spain where Phillip II was decorating the Escorial Palace near Madrid. El Greco, who may have hoped to become a court artist, gained commissions instead for churches in and near Toledo, where he settled. He became a Spanish citizen in 1589 and wrote treatises on art and architecture before his death in 1614.

El Greco, whose reputation faded for two centuries after his death, was "rediscovered" in the mid-nineteenth century by critics who responded positively to the eccentricity of his style. Duncan Phillips discussed El Greco in formalist terms, seeing a connection between his style and that of Cézanne. At the same time, he regarded El Greco as an expressionist, whose work reveals his inner state. Phillips wrote, "he could identify his passion for religion with his passion for dynamic emotional expression by plastic means."

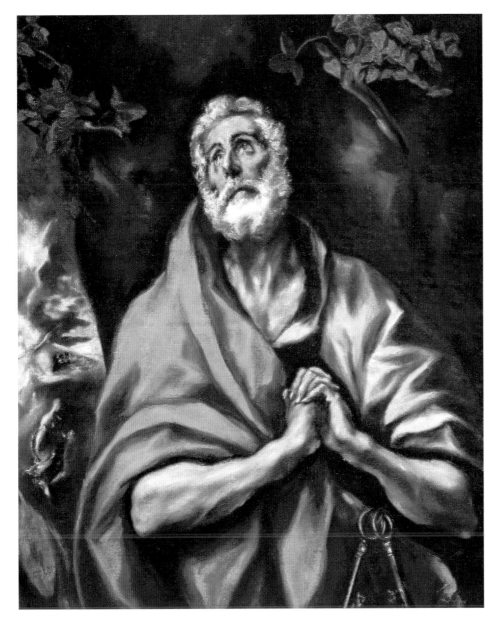

The Repentant St. Peter, ca. 1600–05 or later
Oil on canvas
36 ⅞ x 29 ⅝ inches
(93.7 x 75.2 cm)
Acquired 1922

Juan Gris

b. 1887, Madrid, d. 1927, Paris

After training for two years as an engineer, Gris left Spain in 1906 to settle in Paris. There he moved into the Bateau-Lavoir, the building where Pablo Picasso lived, and began moving in avant-garde circles while supporting himself as an illustrator. Gris had a close friendship with Picasso and Georges Braque, and witnessed their development of cubism. It was in the context of this artistic revolution that Gris became a serious painter. Cubism may have been particularly compatible with Gris's cerebral nature. His knowledge of technical drawing may have made it a particularly attractive compositional system. There is certainly something cool and analytical about Gris's cubism, which also reveals the artist's abilities as a colorist. Although Gris produced some figure paintings, most of his works are still lifes of objects drawn from the café world of early twentieth-century Paris.

Still Life with Newspaper combines a bottle, bowl of fruit, lemon, glass, and newspaper on a table. Unmistakably Spanish in its rich, somber palette of black, gray, brown, and yellow, with dramatic passages of white, it evokes the restrained still lifes of Francisco de Zurbarán,

whom Gris admired. Collage, the kind of cubism that Gris practiced throughout 1914, is clearly reflected in *Still Life with Newspaper*, where the fold in the middle of the clipping from *L'Intransigeant* recalls the artist's use of actual pieces of newspaper pasted onto his vibrant *papiers collés* of that year. The objects in the still life can be read either as shapes that have been cut from a flat surface, moved, layered, and pasted down, or as objects with black shadows that lie next to, rather than behind, them. Gris had a great attachment to painting of the past and saw his work as continuing its traditions rather than breaking with them. "Mine is the method used by the old masters," he said. This was the same sense of continuity and connection in art that informed Duncan Phillips's view of art history and his collecting. No doubt he recognized it in Gris, whose use of color he must also have appreciated. When Phillips bought *Still Life with Newspaper* from Katherine S. Dreier, he already owned *Abstraction*, a small, beautifully colored and textured painting by Gris that he had bought much earlier, in 1930.

Still Life with Newspaper, 1916
Oil on canvas
29 x 23 ¾ inches
(73.6 x 60.3 cm)
Acquired 1950

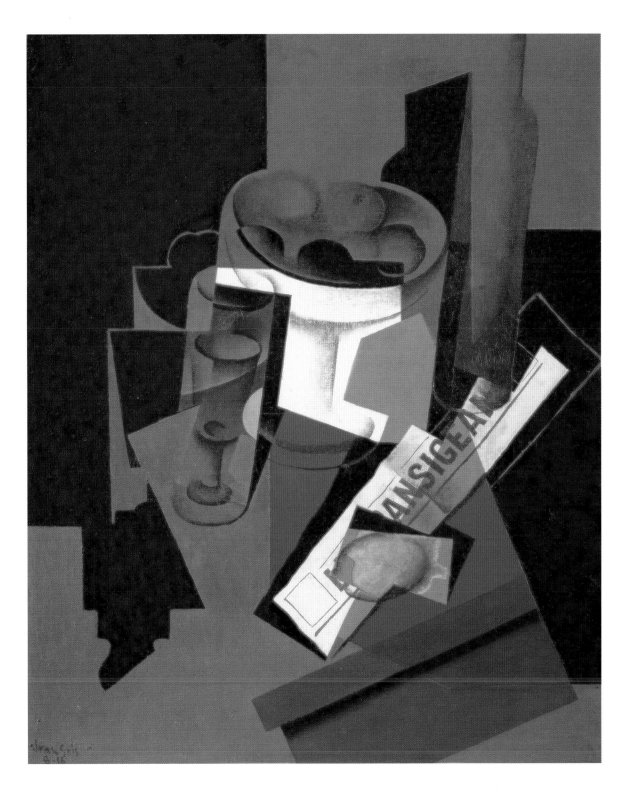

Jean-Auguste-Dominique Ingres

b. 1780, Montauban, France, d. 1867, Paris

Ingres's painting shows a female nude seen from behind and seated on a grass-covered ledge by a stream in a woodland setting. Just behind her and on the right, a tumble of red cloth and the gathered, frilled wrist of a sleeve are draped over the earthy bank. In the dim background, on the other bank of the stream, a reclining nude turns towards a companion. In the stream, a partially draped woman bathes a young girl, and to the right of the bather, the upper torso of a sleeping woman is visible, her face resting on the palm of her hand supported by her bent elbow. If the cool, motionless, meticulously painted central figure in *The Small Bather* seems to breathe different air from her companions, as though posed in front of a painted backdrop, it is because the bather comes from another painting. Indeed, the artist had painted her eighteen years earlier as the *Bather of Valpinçon*. (Valpinçon was the name of the collector who bought the painting, now in the Louvre, Paris.) In that painting her pose was identical. Her turban was similarly wrapped, although it had red and white stripes, and she had the same drapery around her elbow. The red mule lay on the same spot on the floor by her feet. The surroundings were different. In the earlier painting Ingres painted the bather sitting on a bed with white sheets, within an indeterminate setting of black marble, and gray, brown, and white drapery.

In The Phillips Collection's much smaller version, the painter has grassed over the sheets, substituting earth for the valence and placing the sleeping girl's head in the space occupied by a pillow in the earlier painting. Ingres used the central figure in two other works painted after the one in The Phillips Collection. He was clearly fascinated by this female figure that, as a physical type, was current in Ingres's day. Carefully lit to show off her smooth and perfect flesh, and the sinuously rounded and supple curves of her neck and shoulder, the curiously boneless bather suggests the icily erotic marbles by Antonio Canova, Ingres's great Italian contemporary.

Ingres, who studied in Paris under Jacques-Louis David, went to Rome in 1806, stayed there for eighteen years, and later returned for another six. He was a prodigious draftsman and great admirer of High Renaissance Italian painting, especially the work of Raphael. Although in the debate over the relative merits of line versus color, Ingres's support of line is always contrasted with that of Eugène Delacroix for color, Ingres was, in fact, a great admirer of Titian. This is reflected in *The Small Bather* in the warmth that underlies the flesh tints and in the landscape setting that has its origin in the Venetian pastorals of Titian and Giorgione.

Duncan Phillips, a collector for whom color and painterly handling represented the highest values in painting, had no natural affinity for Ingres. He included him in his collection as a foil to Delacroix, considering him representative of what more painterly romantics were struggling against.

The Small Bather, 1826
Oil on canvas
12 ⁷⁄₈ x 9 ⁷⁄₈ inches
(32.7 x 25 cm)
Acquired 1948

Wassily Kandinsky

b. 1866, Moscow, d. 1944, Neuilly-sur-Seine, France

A pioneer of abstract art, Kandinsky dated to the autumn of 1910 his recognition that the formal elements of art were expressive even without subject matter. Yet, the artist continued to refer to the material world in his paintings for many years afterwards. Highly educated and an intellectual, Kandinsky studied ethnography and practiced law before deciding to become an artist at the age of thirty. His religious convictions led him to believe that art was inherently spiritual. Hence, Kandinsky had no use for art as description, which only got in the way of the redemptive, expressive nature of art. Kandinsky put many of his ideas on art in writings that describe his efforts to create a language of color. *Autumn II*, painted while he was writing *On the Spiritual in Art*, demonstrates some of his beliefs about the expressive powers inherent in particular colors. *Autumn II* evokes rather than represents an autumn day by a lake in the mountains. It does so through Kandinsky's system of assigning symbolic values to color: yellow he connected to verticality and to "the last forces of summer in the brilliant foliage of autumn"; blue, to infinity, horizontality, and superhuman sorrow; and green to calm. The forms suggest, rather than describe. Line, like color, speaks a language. The squiggly line in *Autumn II*, for example, does not represent the shore. Kandinsky believed that "line freed from delineating . . . functions as a thing in itself, its inner sound . . . receives its full inner power."

Kandinsky's *Sketch I for Painting with White Border (Moscow)* is a study for *Painting with White Border (Moscow)* in the Solomon R. Guggenheim Museum, New York. The Phillips Collection's study appears as part of the final painting, the

Autumn II, 1912
Oil and oil washes on canvas
23 ⁷⁄₈ x 32 ¹⁄₂ inches
(60.5 x 82.5 cm)
Acquired 1945

center-left area. Although he would not pin himself down on the exact significance of some of the elements in the painting and warned against over-interpretation, the artist wrote at some length about its themes. These include highly abstracted memories of Kandinsky's "gold-crowned" native city that recur in many of the painter's works. They can be recognized by comparing different paintings and constitute a private language. Among the references are elements of traditional Russian folk iconography including the troika, the three yellow-rimmed arcs at the upper left, and an abstraction of the backs of three horses. Most important is the blue rider galloping diagonally up the painting

from lower right, his white lance extending across the picture plane. Kandinsky, who was highly active in avant-garde circles in Munich and nearby Murnau where he also lived, helped found several artists' groups including Der Blaue Reiter (the Blue Rider)whose members wanted to renew the spiritual dimension of art. Kandinsky associated the blue rider with the patron saint of Moscow, Saint George, found in many Russian icons. Kandinsky's blue rider appears in many of the artist's works. Here, in a scene evocative of Kandinsky's description of a Moscow sunset, the blue rider charges a dragon on the left, while an angel flies overhead.

Sketch I for Painting with White Border (Moscow), 1913
Oil on canvas
39 $\frac{1}{8}$ x 30 $\frac{7}{8}$ inches
(100 x 78.3 cm)
Gift from the estate of Katherine S. Dreier, 1953

Paul Klee

b. 1879, Münchenbuchsee, Switzerland, d. 1940, Muralto, Locarno, Switzerland

The sheer number of works (thirteen) by Klee in The Phillips Collection testifies to Duncan Phillips's enthusiasm for the intensely personal output of an artist whom he called "a dreamer, a poet, and a brooding rebel." Phillips bought his first Klee in 1930 and eleven more between 1938 and 1948. The thirteenth came to The Phillips Collection from the estate of Katherine S. Dreier.

Paul Klee grew up in Switzerland, the only child of musician parents. Having studied painting at the Munich Academy, he later settled in Munich, then a center of avant-garde artistic activity. Klee's ideas about art had an enormous influence on the Bauhaus, where he taught from 1920. In 1931 he left to teach at the Düsseldorf Academy. Pursued by the Nazis, Klee fled to Switzerland in 1933 and remained there for the rest of his life.

Klee began his career as a draftsman and printmaker, working on a very small scale. The small scale is also characteristic of most of his paintings. His graphic training stayed with him his entire life, as is demonstrated by the lines that characterize so much of his art. Klee was essentially a visual poet, combining formal invention with a linguistic—though not invariably verbal—dimension to create mysterious, whimsical, and frequently runic works. In *Cathedral*, Klee plays with different kinds of notation, architectural and musical, both of which he completely understood. As a teacher at the Bauhaus, he taught a required basic design course, using many of the elements visible in *Cathedral*, the arrows and semicircles, for example, to demonstrate design principles. Horizontal bands carry the various signs across

the white grid that Klee has imposed on the picture plane, turning plans, elevations, and views of the cathedral into a musical score. On the right side of the painting, musical notation takes over, a reminder, perhaps, of the music heard within the cathedral and perhaps of architecture's status as frozen music. Klee gives us plans and elevations, the rhythmic repetitive nature of architectural design, and through a tonal overlay, its lights and darks. Playing with the idea of the picture as an architectural plan, Klee added his signature in the upper left corner over a fictive tear in the paper. The building reaches towards the heavens in the manner of cathedrals, spearing a crescent moon as it presses against the sky. At the upper left, the word Montgolfier, a name associated with balloon ascents, serves as the legend on his plan. The watermark of the painting's paper surface (the Montgolfiers of balloon fame were also innovative paper manufacturers) is clearly revealed by a thin oil wash. Klee must have been delighted by this effect. His assimilation of the watermark's lettering into the picture illustrates the nature of his artistic process.

In 1914 Klee went to Tunisia, a formative experience that resulted in his breakthrough as a colorist. Thereafter, Klee associated North African travel with color. He wrote in 1927, "This is what I search for all the time: to awaken sounds, which slumber inside me, a small or large adventure in color." *Arab Song* is one of the visual melodies that a 1928 journey to Egypt aroused in him. The means Klee used to interpret his trip were as simple and reductive as hieroglyphs. Phillips noted, "With only a raw canvas stained to a few pale tones, he evoked a

Cathedral, 1924
Watercolor and oil washes on paper, mounted on cardboard and wood panel
11 $^7/_8$ x 14 inches
(30.1 x 35.5 cm)
Acquired 1942

Arab Song, 1932
Oil on burlap
35 ⁷/₈ x 25 ³/₈ inches
(91.1 x 64.5 cm)
Acquired 1940

hot sun, desert dust, faded clothes, veiled women, an exotic plant, a romantic interpretation of North Africa." The composition of *Arab Song* is mysterious and ambiguous, framing as it does both a face and a view through a window of a desert landscape with tree, hills, and oasis.

When he lived in Munich during the 1910s, Klee associated and exhibited with the Blaue Reiter artists. He shared their belief in the spiritual sources of art as well as a taste for the artifacts of tribal cultures and the art of children and the insane. Klee himself aspired to an imaginative innocence, wishing he were ignorant of Western artistic conventions. In *Picture Album*, figures, symbols, patterns, and shapes suggest a rich compendium of ancient-seeming red and ochre hieroglyphs, some suggestive of Picasso's work. Painted as though freed from a thin veil of gray-green paint, they seem to have been excavated and laid bare by the artist. Klee undoubtedly found many of the neolithic and tribal motifs adapted in *Picture Album* in photographs published in *Cahiers d'art*, an important art journal that often included works by Picasso. When, in 1937, Adolf Hitler condemned modern art, he could have had *Picture Album* in mind, complaining about "works which might, perhaps, have been produced in some Stone Age, ten or twenty thousand years ago." Klee's works vanished from public collections but appeared in the notorious 1937 Nazi exhibition of "degenerate art."

In *The Way to the Citadel*, red arrows point the way across a surface of colored shapes reminiscent of stained glass and apparently studded with windows, recesses, and stairs. But the seemingly rational architecture turns out to be impossible and impenetrable. The arrow motif appears often in Klee's work. He wrote about its meaning, noting its importance as a symbol raising the question, how to extend one's reach. For Klee, it also pointed up the tragic contrast between a capacity for metaphysical exploration and physical limitations. In both the painting and its title, Klee probably intended to refer to a couple of his travel experiences. From Corsica, in 1927, he wrote to his wife about his inn: "You go to your bedroom by following the arrow, up a very steep alley like those in Genoa, then around a corner, you enter the rear of the adjacent house by climbing high, very high, steps into the second floor." In a letter he wrote to his son the next year from Egypt, he described a climb he made to the citadel for a view over Cairo towards the pyramids.

Picture Album, 1937
Oil on canvas
23 ⅝ x 22 ¼ inches
(60 x 56.5 cm)
Acquired 1948

The Way to the Citadel, 1937
Oil on canvas, mounted on cardboard
26 ³⁄₈ x 22 ³⁄₈ inches
(67 x 56.8 cm)
Acquired 1940

Oskar Kokoschka

b. 1886, Pöchlarn, Austria, d. 1980, Montreux, Switzerland

As a portraitist, in the early years of his career, Kokoschka was not interested in externals, but in gestures. In his dramatic and intense portrait of Lotte Franzos (1881–1957), this did not sit well with the subject. Kokoschka wrote to her: "Your portrait shocked you; I saw that. Do you think that the human being stops at the neck in the effect it has on me? Hair, hands, dress, movements are all at least equally important . . . I do not paint anatomical preparations." The wife of a prominent lawyer, Franzos was in her twenties when Kokoschka painted her. The tension that infuses the portrait undercuts the elegance of her presentation. This comes from the conflicting impulses Kokoschka saw expressed in her nervous hands, one clutching her dress, while the other seeming to want to gesture. Young Franzos was perhaps more inhibited than her modern, wavy bob and her patronage of the avant-garde suggested.

Kokoschka shows her seated against an indeterminate background, surrounded by transparent blues, reds, and yellows, with much of the ground exposed. Decorative marks scratched in the thin paint radiate from the figure, blurring it like ghostly ectoplasm, as in a "spirit photograph." Kokoschka, who was perhaps in love with his patron, said: "I painted her like a candle flame: yellow and transparent light blue inside, and all about, outside, an aura of vivid dark blue She was all gentleness, loving kindness, understanding."

Duncan Phillips said Kokoschka was "one of our favorite artists of the twentieth century." Phillips may have been predisposed to like Kokoschka's work, believing as he did that expressionism had descended from El Greco. Kokoschka and Phillips maintained a friendly correspondence and met when the painter visited Washington.

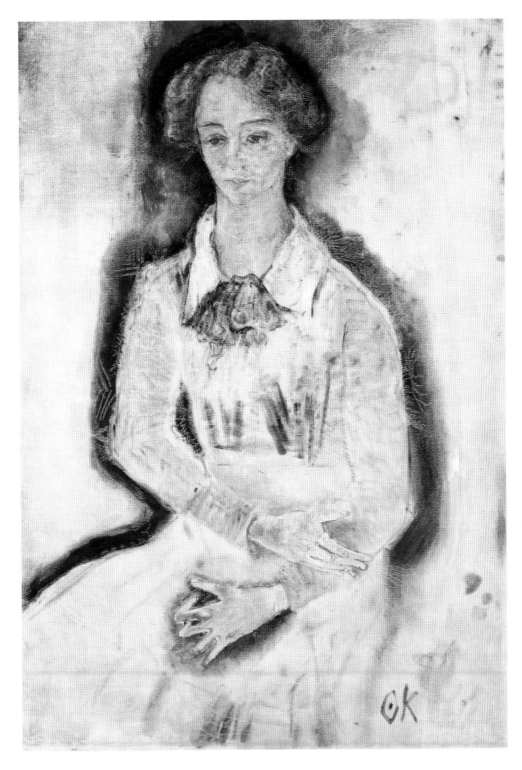

Portrait of Lotte Franzos, 1909
Oil on canvas
45 ¼ x 31 ¼ inches
(114.9 x 79.5 cm)
Acquired 1941

Franz Marc

b. 1880, Munich, d. 1916, Verdun, France

Marc abandoned the study of philosophy and theology to take up painting as a career. A sort of pantheist with intellectual roots in German romanticism, Marc invested animals, his preferred subjects, with human and moral qualities. For example, the cow, he believed, represented steadfastness, the bird stood for spirituality, and the horse signified power. Marc himself owned a herd of domesticated deer, the subject of The Phillips Collection's painting. For Marc, the animal served as a metaphor for vulnerability, innocence, and gentleness. Of his paintings of deer, Marc said that he wished to convey their feelings. In *Deer in the Forest I* five deer rest on the ground. The treatment of their surroundings as fragmented, interlocking, colored planes echoes the way he handles their bodies, reflecting Marc's belief in the interconnectedness of all life, matter and spirit, at the same time as providing a design equivalent for camouflage at a naturalistic level. The painting may allude to the legend of Saint Julian Hospitator as told by Gustave Flaubert. Marc read the story and made a gouache of a scene from it in 1913. The painting is, in any case, dense with nineteenth-century romantic allusions. The spindly trees around the deer are painted white, perhaps suggesting their immaterial nature. Marc, cofounder with Kandinsky of the Blaue Reiter group, shared a belief in colors as vehicles of spiritual meaning. The central tree may be Goethe's archetypal plant, and the bird, perhaps a divine messenger. In the tree branches, an energetic white looping line signals a spiritual presence. Marc's animal paintings in 1913 contain many images of apocalyptic destruction and regeneration, and in The Phillips Collection's painting there are suggestions of flames and smoke. Frighteningly, Marc's romantic world-view included the belief that immolation of a corrupt world in the fire of war would bring about its regeneration as well as purification. His longed-for holocausts were realized in the slaughter of the First World War that claimed his life at Verdun.

Duncan Phillips was not initially enthusiastic about German art, describing it in 1927 as "given to nightmare 'expressionism' and to sexual fantasies." The Great War probably did not help. However, a few years later, he made a list of artists to consider adding to the collection and included Marc. *Deer in the Forest I* appeared in installations of works that shared its formal qualities.

Deer in the Forest I, 1913
Oil on canvas
39 ¾ x 41 ¼ inches
(100.9 x 104.7 cm)
Gift from the estate of Katherine S. Dreier, 1953

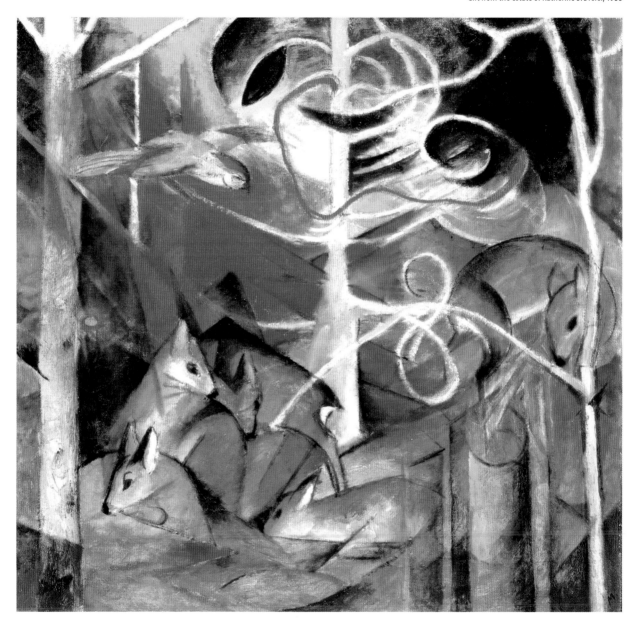

Henri Matisse

b. 1869, Le Cateau-Cambrésis, France, d. 1954, Nice

Matisse first gained attention for the very subjective paintings in bright antinaturalistic colors that he exhibited with André Derain and Maurice Vlaminck at the Salon d'Automne in 1905 and that earned them the name *fauves* (wild beasts). Matisse's subsequent efforts to refine his work by, as he said, subjecting his intuitively sensuous and personal responses to life to intellectual rigor led to an exquisite balance of color and line in his art. Even so, late in his career he still felt the "eternal conflict of drawing and color," a conflict that was finally resolved in the paper cutouts of his last years.

Matisse worked to the very end of his long life. His last paintings were a series of interiors. Painted when he was seventy-nine, in the year of his first designs for the Dominican Chapel in Vence, *Interior with Egyptian Curtain* demonstrates the artist's vigorous approach and endless capacity for innovation. From 1943 he lived in a villa on the south coast of France; in a magazine article published in May 1948, he wrote about the stirrings he felt at the coming of spring to the Mediterranean. In *Interior with Egyptian Curtain* Matisse combines, with the wild energy granted to some great artists in old age, several elements related to the theme of growth, a theme that is common in his paintings throughout his career. The wintry blackness of the curtain teems with life, its pulsating red and green motifs possibly metaphors for generation.

The pomegranate, shown in section with its faceted seeds visible, refers to fertility, the vine to creative energy, and the spear motif in the curtain's border to maleness. The palm tree, seen through the window, is a reference to longevity. Life-giving light from the swirling palm fronds, painted in slashes of green, yellow, and black against a bright blue sky, explodes into the darkness of the room, warming fruits—pomegranates perhaps—in a bowl on the coral tabletop. The Egyptian curtain itself was one that Matisse owned. Its bold and brightly colored appliquéd design was a source for the paper cutouts Matisse was working on when he made this painting and which occupied him until his death six years later.

Duncan Phillips's first reaction to Matisse's work was hostile. Among the epithets he used to describe it in 1914 were "crude" and "insanely depraved." By 1927 Phillips's understanding of postimpressionism had grown and his attitude had changed. He was ready now to acknowledge Matisse as "a daring and lucid agitator for direct decorative expression and luminous chromatic experiment . . . the brilliant descendant of a great Oriental tradition" Phillips bought several works by Matisse, some of which he deaccessioned, settling finally on the *Studio, Quai Saint-Michel* (1916), which he bought in 1940, *Interior with Egyptian Curtain,* and a late drawing, *Head of a Girl* (1946).

Interior with Egyptian Curtain, 1948
Oil on canvas
45 ³/₄ x 35 ¹/₈ inches
(116.3 x 89.2 cm)
Acquired 1950

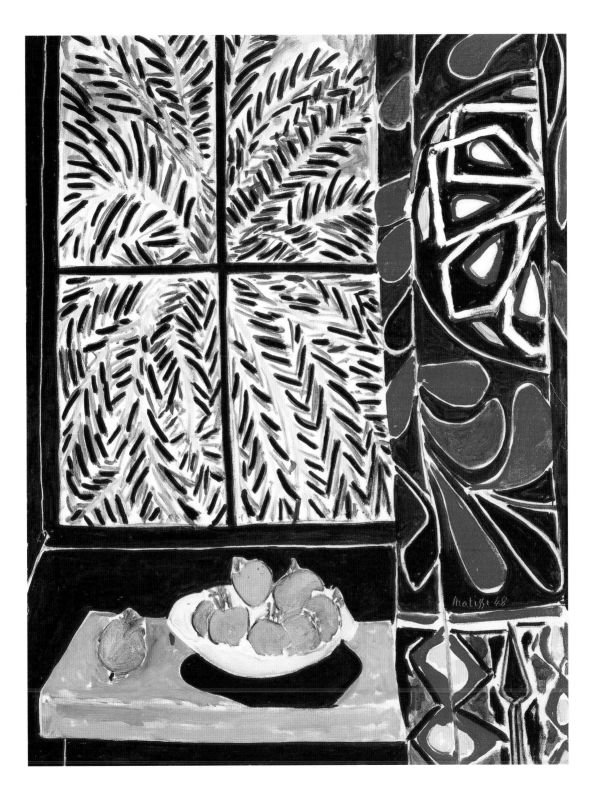

Claude Monet

b. 1840, Paris, d. 1926, Giverny, France

By the end of 1877 Monet found himself in bad financial straits because his works were not selling. Early the next year, he moved with his family to Vétheuil, fifty miles northwest of Paris. The three years he spent there were personally difficult. The Monets shared their home with Alice Hoschedé, the wife of Monet's newly bankrupted patron, Ernest Hoschedé, and her children. Monet's second son, Michel, was born in March 1878, and his wife, Camille, died in September 1879. During his time in Vétheuil, Monet exhibited with the impressionists only once, in 1878, and infuriated Edgar Degas and Camille Pissarro by submitting work to the official Salon of 1880. At Vétheuil, Monet began to move in the direction of working in series. *The Road to Vétheuil* is the last of five paintings depicting the road leading into the village from La Roche-Guyon. All five versions show the same scene in different weather conditions. These paintings anticipate Monet's 1890 series, the Haystacks, Poplars, and Rouen Cathedral, with the difference that Monet did not conceive the views of the road as a series.

The Road to Vétheuil depicts a rural landscape with no trace of modern life, no anecdotal content, and only minimal evidence of human life. It shows a rough dirt road leading into the village in the late-afternoon light of an autumn day. Monet's house occupies the center of the painting, the spatial organization of which employs traditional perspective. Monet paints the scene using complementary colors in a pastel range, warm and cool—salmons, blues, pinks, greens, and golds—building the picture out of small patches of paint. In the foreground, he applies the paint thickly, using less in the background, where exposed areas of tan-colored primer are used as part of the color scheme. Duncan Phillips, who listed *The Road to Vétheuil* among his fifteen best purchases of 1918–19, called it a landscape capturing a moment.

Having grown up in Le Havre, Monet often painted on France's north coast. *Val-Saint-Nicolas, near Dieppe (Morning)* shows the view to the east, from the top of the cliffs in the direction of Dieppe. It is one of more than fifty cliff views from three individual series that Monet painted in 1896–97 in Normandy. As in *The Road to Vétheuil*, the landscape reveals no human traces. Here, Monet shows only cliffs, sea, sky, and the coastline, faintly visible as it stretches away in the distance. The northern morning light suppresses local color. Phillips had bought and sold four other paintings by Monet in his search for such a landscape, where "individualities of contour . . . [are] lost in the ambience of light." The collector thought it one of the most beautiful he had ever seen.

The Road to Vétheuil, 1879
Oil on canvas
23 3/8 x 28 5/8 inches
(59.4 x 72.7 cm)
Acquired 1920

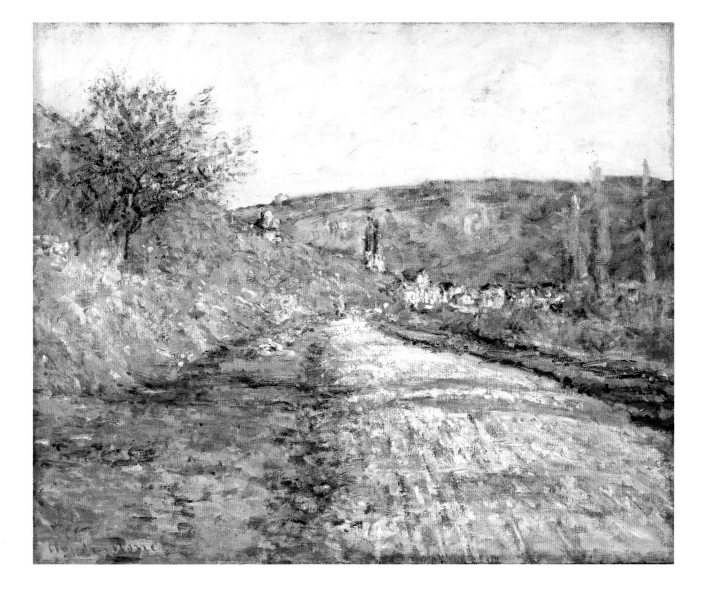

Val-Saint-Nicolas, near Dieppe (Morning), 1897
Oil on canvas
25 ½ x 39 ⅜ inches
(64.8 x 99.9 cm)
Acquired 1959

Berthe Morisot

b. 1841, Bourges, France, d. 1895, Paris

Berthe Morisot and her sister Edma, daughters of upper-middle-class parents, took drawing classes and studied painting out-of-doors with Corot. Edma gave up art when she married, but Berthe rejected the amateur status conventionally accepted by women artists at the time. That many of those who bought her works were the most important artists of her time indicates the respect with which she was regarded professionally. Morisot exhibited at the Salon from 1864 to 1868 and became the only female founding member of the impressionist circle of painters, participating in seven of their eight exhibitions. She was a particularly close colleague of Edouard Manet and married his brother, Eugène, in 1874.

Two Girls was painted about a year before Morisot's early death, after her husband had died and after she and her daughter Julie had moved into an apartment on rue Weber in Paris, turning its drawing room into a studio. She always painted on a small scale and would put away her canvases when receiving visitors. *Two Girls* is one of Morisot's many intimate images of women shown in the privacy of their homes. Although Julie was Morisot's favorite model, the figures in *Two Girls* were professionals. One of them, the disheveled blonde with hair tumbling sensuously about her, her camisole slipping off her shoulders, is about to wash her feet, while the brunette, with pearly skin and tidy hair, wearing a *peignoir*, looks on. But, the tasks of *la toilette* are only an excuse for the real subject of the painting: the informal, dreamy atmosphere in which they are performed. Morisot's luminous harmonies in blue, pink, gold, silver, and white, much in evidence in this painting, attest to her love of the radiant works of François Boucher, from which she learned how to infuse her paintings with light through the use of white. In the last decade of her life she was a very close friend of Renoir, who shared her taste for the rococo. His influence can be seen in the outlining strokes that make the volumes of the figures stand out from their setting.

Morisot typically painted from the center out and did not work the corners of her canvases, and in *Two Girls* some places on the edges are unpainted. The bold, rapid brush strokes are characteristic of her work. They define forms at the same time as they dissolve them into abstraction. Although it is an understatement to say that Morisot did not overwork her paintings, evidence suggests *Two Girls* is an unfinished work because it bears a studio stamp rather than the artist's signature.

Duncan Phillips appreciated Morisot particularly as a colorist and understood her importance in the development of modern painting. He wrote, "Her line led to Lautrec and her color to Redon and Bonnard—stylists all of them and all painters of the intimate and the idiomatic expression."

Two Girls, ca. 1894
Oil on canvas
25 ⁵⁄₈ x 21 ¼ inches
(65 x 54 cm)
Acquired 1925

Pablo Picasso

b. 1881, Málaga, Spain, d. 1973, Mougins, France

Picasso's art, and probably his persona too, represented challenges to Duncan Phillips. He found it difficult to assimilate cubism and its sense of rupture, with which Picasso's name is synonymous, into his vision of modern art as a continuation of the art of the past. Although Phillips accepted cubism as an integral feature of twentieth-century painting, as his commitment to Georges Braque's synthetic version of cubism makes clear, he suspected that Picasso's endless stylistic innovations suggested insincerity. Nevertheless, Phillips liked the artist's early work.

Like other introspective and melancholy paintings of Picasso's Blue Period (1901–04), *The Blue Room* can be read in the symbolist language of the nineteenth century as documenting Picasso's own sense of isolation as a young foreigner in Paris. Although the privacy of the subject, an interior with a solitary nude bathing, recalls Edgar Degas, Picasso's focus here, unlike Degas's, is expressive rather than formal. Picasso exploits the pose in *The Blue Room* for its pathos as he does in other canvases around this time, as in, for example, *Woman Ironing* (1904; Solomon R. Guggenheim Museum, New York). In *The Blue Room*, the thin woman with hunched shoulders droops over the bath. The dejection and world-weariness of her gesture are echoed by the color of her surroundings: in the color language of romanticism, blue signified spiritual yearning. Blue also pervades the paintings of Pierre Puvis de Chavannes, an important influence on Picasso's early work. In *The Blue Room* the simplified contours of the flat figure, its stillness, and color echo the style of Puvis de Chavannes. Picasso also drew inspiration from

his adopted countryman, El Greco, for the attenuation and chalky whiteness of the nude's limbs. Above the bed, the snap of Henri de Toulouse-Lautrec's dancing figure of *May Milton* contrasts sharply with the mood of the figure in the room, but its presence also recalls Picasso's debt to that artist's sinuous outlines, as is evident in the figure of the bather. Phillips, whose response to Picasso was complex, called *The Blue Room* "a succulent, sumptuous little picture." He noted its rhythmical design and said, "in spite of the realism of the bed and the early morning light the distortion and unreality of the figure are appropriate to a scene which is already more of a Hispano-Moresque pattern than a picture."

Four years after painting *The Blue Room*, Picasso's mood lightened somewhat as did his palette. In his Rose Period (1905–06) a cast of wistful acrobats and circus folk replaced his solitary *fin de siècle* depressives. Picasso, who throughout his career worked as a sculptor as well as a painter, typically explored the interrelationships of both media, and *The Jester* is a sculpted version of one of the figures that occur in his Rose Period paintings. The sad dignity of the jester's expression is mocked by his hat, which is both silly and, in its suggestion of a crown of thorns, haunting. This associates it with images of Christ as the Man of Sorrows. Picasso's bust can be understood in relation to the romantic theme of sad clowns that developed in French literature and art in the nineteenth century. Honoré Daumier, an artist much admired by Picasso, made a portrait of the great mime Deburau as a sad Pierrot, as well as drawings of little troupes of dispossessed

The Blue Room, 1901
Oil on canvas
19 ⁷/₈ x 24 ¹/₄ inches
(50.4 x 61.5 cm)
Acquired 1927

jugglers and acrobats as wanderers, harassed by the government, trying to eke out a living in a hostile world.

Picasso first treated the subject of bullfighting in 1900. After a trip to Spain in 1933, the artist took up the theme again in a series of paintings and drawings. In a highly colored image of ferocious energy, The Phillips Collection's abstracted *Bullfight* shows the savage clash of a bull with a white horse. Lanced by a picador, the bull gores the rearing, screaming horse, whose blood pours from a gaping wound. The flying cape of the matador and the figure of the picador protectively frame the ritual murder that takes place inside the bullring. The focus of the composition is entirely on the drama, with the spectators reduced to flecks of paint and their surroundings rendered in the most generalized way. *Bullfight* translates life's polarities into the language of bullfighting, itself an ancient and highly symbolic activity: good and evil, light and dark, male and female, life and death. These oppositions may directly apply to Picasso, who as the creative artist destroying conventions and seeding new ground, can be identified with the energetic and highly sexed bull that symbolically penetrates the virginal horse. Although Phillips often found Picasso's work impersonal, he clearly recognized the expressive quality of *Bullfight*. He wrote: "This abstraction is vividly expressive of the light and excitement of a bull fight in the Spanish sun. It is a composite of Picasso's life extending from his racial background to his latest emotions in the bull pen of Europe today."

The Jester, 1905
Bronze
16 ⅛ inches
(40.9 cm)
Acquired 1938

Bullfight, 1934
Oil on canvas
19 ⁵/₈ x 25 ³/₄ inches
(49.8 x 65.4 cm)
Acquired 1937

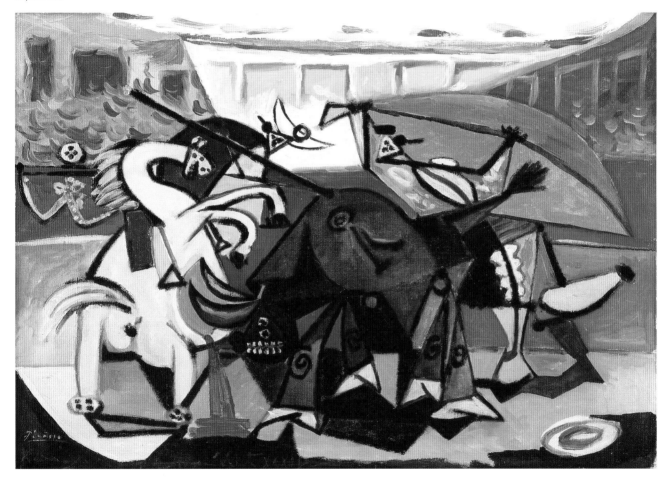

Pierre Puvis de Chavannes

b. 1824, Lyons, d. 1898, Paris

Two of the paintings in The Phillips Collection by Puvis de Chavannes are sketches for murals. One, *Massilia, Greek Colony*, is squared-up for transfer to a much larger final canvas as part of a mural program commissioned in 1867 by the city of Marseilles for the decoration of the Palais Longchamp, the new municipal museum. The city had experienced tremendous expansion during the nineteenth century as a result of the increase in the number of French territories overseas, including Algeria, colonized in the 1830s. This, with the opening of the Suez Canal, brought more and more traffic to its port. The commission specified two murals on canvas for the museum's great staircase, one showing Marseilles in pagan times, the other Christian Marseilles. The Phillips Collection's paintings have the same titles and compositions as the finished murals but are less than a quarter of their size. They also lack their decorative borders.

Massilia, Greek Colony represents pagan, pre-Christian Marseilles with a scene of daily life in the ancient world. The classically draped inhabitants of the future city's site are shown talking, cooking, and inspecting a length of cloth, in a bare, timeless, and dreamlike landscape, against a background of coastline, empty sea, and sky. The classical world they

Massilia, Greek Colony, ca. 1868–69
Oil on canvas
38 ⁷/₈ x 57 ⁷/₈ inches
(98.9 x 147 cm)
Acquired 1923

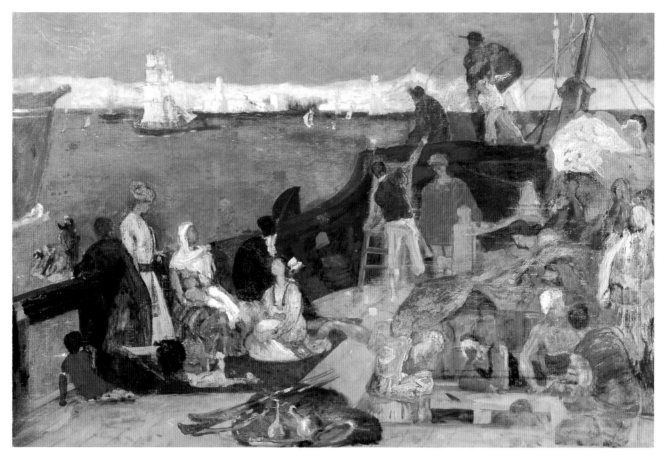

Marseilles, Gateway to the Orient, ca. 1868–69
Oil on canvas
38 ³/₄ x 57 ⁵/₈ inches
(98.8 x 146.5 cm)
Acquired 1923

inhabit is a generalized one, without the archaeological details that so many late-nineteenth-century painters found irresistible. The simplified figures, shown frontally or in profile, extend across the composition. Movement is frozen.

In *Marseilles, Gateway to the Orient*, the city has become a maritime hub, its shipping lanes crowded with large and small vessels. Puvis shows it from the point of view of a traveler approaching the city by sea. The picture's foreground depicts the ship's foredeck. On it, exotically costumed travelers— "the different races of the Levant. An Armenian, a Jew, a Greek, an Arab," according to Puvis— congregate as the ship's crew work around them and the ship advances slowly across the brilliant, green-blue sea towards the shimmering city. Although this composition may have been inspired by the completion of the Suez Canal in 1869, the scene's modernity is as nonspecific and timeless as the Greek world presented in the painting's pendant.

Although not well known today to the nonspecialist public, Puvis was an important influence on late-nineteenth- and early twentieth-century art. His decorative, planar, and reductive approach to painting had a particularly potent effect on the symbolist artists. A long list of painters affected by just one of his enigmatic easel paintings, *The Poor Fisherman* (1881; Musée d'Orsay, Paris), includes Paul Gauguin, Vincent van Gogh, and Pablo Picasso. Puvis worked mainly as a decorator, with commissions for monumental murals coming from institutions all over France. He even received one from the Boston Public Library. Influenced by Pompeian frescoes and Italian primitives, Puvis sought to preserve the wall's flat plane, which he achieved with broad contours and simplified forms, suppressing contrasts of light and shade to minimize modeling, all of which can be seen in the Marseilles paintings. He blotted his paintings to remove excess oil in his pursuit of a flat, opaque look. Puvis tended to use pale, chalky colors that harmonized with the stone or plaster surrounding the murals. However, The Phillips Collection's sketches use deep and jewel-like colors that attracted Duncan Phillips. He commented that they suggested Puvis's "wistful longings for romantic freedom of color and design in spite of his almost pure architectural attitude."

Odilon Redon

b. 1840, Bordeaux, d. 1916, Bièvres, France

Redon's isolated upbringing resulted in his living very much in his own imagination. A contemporary of the impressionists, Redon was uninterested in their visual objectivity and concentrated instead on the subconscious. He created a vast body of charcoal drawings, many of them depicting fantastic, imaginary beings, rendered all the more convincingly because of his knowledge of anatomy and osteology. Redon, who learned lithography from Rodolphe Bresdin, produced velvety black-and-white lithographs, which he called *Les Noirs*. His friends included symbolist writers such as Stéphane Mallarmé and the Nabis painters, who liked Redon's bizarre, mystical works and regarded him as a mentor. Pierre Bonnard greatly admired him and commented on the debt his generation of artists owed to Redon. Although Redon considered black "the prince of colors," in the 1890s he started working in color. *Mystery* is one of many paintings he made late in his career of a head with flowers against a background of decorative colors. Duncan Phillips interpreted the androgynous figure touching its chin as "intellect meditating on the brief life of flowers." Redon himself wrote that the meaning of *Mystery* lay in ambiguity, in "forms which will be, or which become according to the state of mind of the beholder." In 1926 Phillips displayed *Mystery* in an exhibition of paintings by eleven American painters including Arthur Dove, Marsden Hartley, and Georgia O'Keeffe. Phillips, whose own approach to art was deeply personal, contended that they shared a desire to convey their emotions through form and color, and that Redon, an artist who "opened an avenue of *escape*," was their presiding genius.

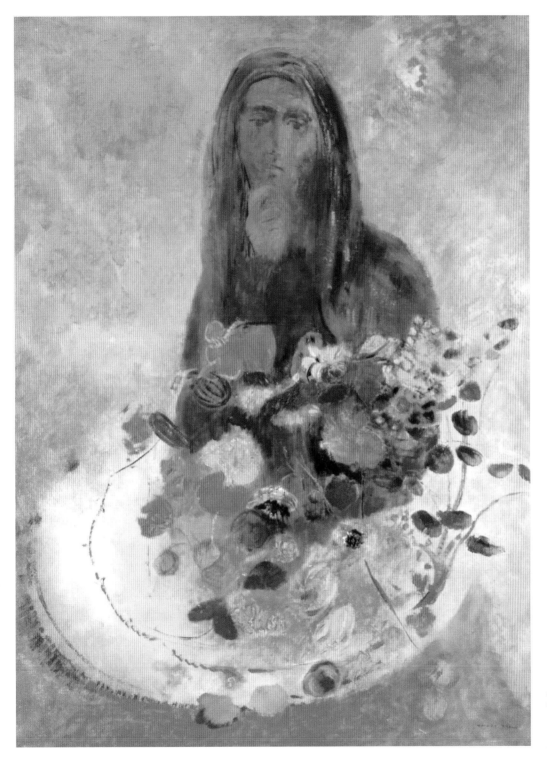

Mystery, ca. 1910
Oil on canvas
28 ³/₄ x 21 ³/₈ inches
(73 x 54.3 cm)
Acquired 1925

Pierre-Auguste Renoir

b. 1841, Limoges, d. 1919, Cagnes-sur-Mer, France

Renoir's *Luncheon of the Boating Party*, the most famous and perhaps the best-loved painting in The Phillips Collection, depicts some of life's great pleasures: glorious weather, a day on the river, food and wine, and the company of friends. The painting commemorates no particular event but reflects and celebrates modern life and the new social realities of the late nineteenth century. It is an updated *fête champêtre*. Renoir's young, attractive sitters, dallying over lunch at the Restaurant Fournaise on an island at Chatou, outside Paris, are representatives of the newly ascendant middle class enjoying leisure, once the preserve of the gorgeously costumed aristocrats who frolicked in arcadian images by such eighteenth-century masters as Antoine Watteau and Jean-Honoré Fragonard.

The sitters were Renoir's friends. His fiancée, Aline Charigot, coquettish as she plays with her dog in the foreground, sits across the table from Renoir's great friend, wealthy Gustave Caillebotte, impressionist painter, oarsman, and boat designer. Alphonse Fournaise, the restaurateur's son, dressed in boating clothes, leans against the railing, and further along it, a young woman, who remains unidentified, chats with former cavalryman Baron Raoul Barbier. Actress Ellen Andrée sits drinking, opposite the baron. At the back on the right, Renoir's friend Paul Lhote, in a straw hat, has his arm around the waist of Jeanne Samary, a famous actress at the Comédie Française, in conversation with bowler-hatted Eugène Pierre Lestringuez, of the Ministry of the Interior. Wearing a top hat, Charles Ephrussi, a financier and the editor of the *Gazette des*

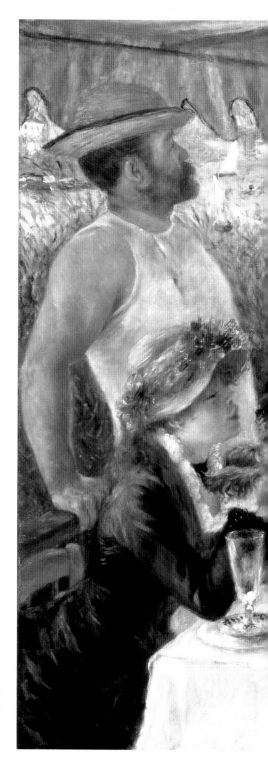

Luncheon of the Boating Party,
1880–81
Oil on canvas
51 ¼ x 69 ⅛ inches
(130.2 x 175.6 cm)
Acquired 1923

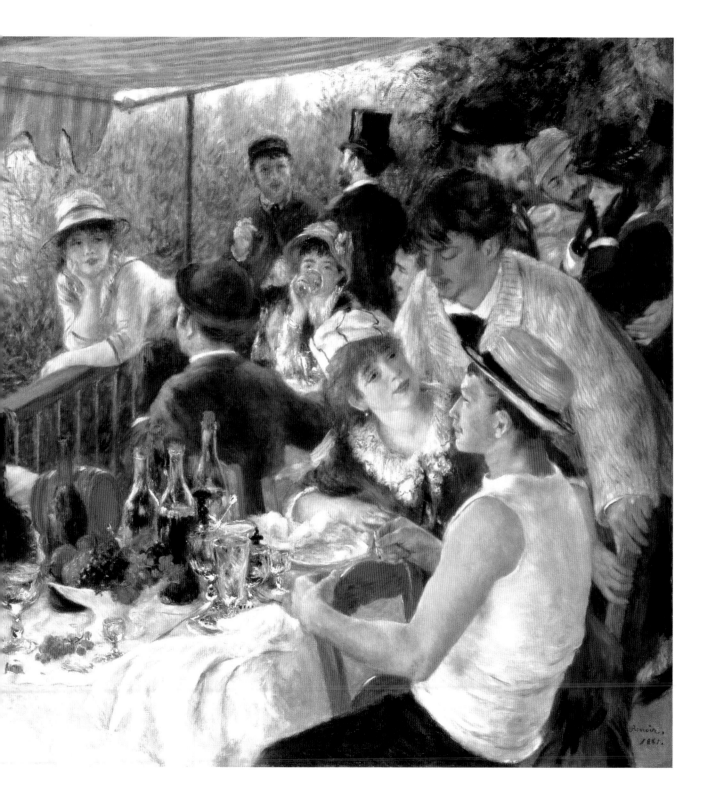

beaux-arts, talks to a younger man, possibly poet Jules Laforgue. The girl in the foreground on the right is Angèle, an actress and model, and the man leaning over her is a journalist, Maggiolo. But as Duncan Phillips's wife, Marjorie, said, their identities were not important because they were "everyman."

Luncheon of the Boating Party is much larger than most impressionist paintings. Its composition is intricate and complex, including as it does, in the tight space of the balcony, so many group portraits as well as an opulent still life and elements of a landscape, yet Renoir did not make studies and sketches for this ambitious painting. It is believed that although the picture was probably completed in his studio, much of it was painted outside at Chatou. Just managing the comings and goings of so many sitters must have taken patience and organization, although it was not necessary to have them all present at once.

By the time he painted *Luncheon of the Boating Party*, Renoir had already had some commercial success, and the painting was well received. The dealer Paul Durand-Ruel bought it immediately, sold it soon afterwards, but very quickly reacquired it. Duncan Phillips saw the painting first in 1911 and wrote warmly about it in his travel journal. In 1923 on a trip to Paris with his wife, Phillips saw it again, while lunching at Durand-Ruel's gallery, fell in love with it, and started negotiating to buy it. He knowingly paid a record price for it, realizing that by doing so he was adding to the aura and reputation of the painting and to its drawing power. The day after closing the deal, Phillips, in a letter to his treasurer about the purchase of "*one of the greatest paintings in the world*," presciently wrote: "Its fame is tremendous and people will travel thousands of miles to our house to see it."

Pierre-Auguste Renoir and Richard Guino

(b. 1890, Girona, Spain, d. 1973, Anthony, France)

*M*other and Child depicts Renoir's wife Aline as a young woman nursing the couple's infant son, Pierre. Based on *Maternity* (1885; Museum of Fine Arts, St. Petersburg, Florida), the work was intended as a monument for Aline's grave, although not used. She had died in 1915, exhausted by the stress of running back and forth between Carcassonne and Gérardmer, where the couple's sons, Pierre and Jean, lay in hospital, having been seriously wounded in the First World War. Renoir had been making sculpture since 1907 in spite of his crippling arthritis, but after 1910, when he was partially paralyzed by a stroke, he could no longer use his hands to model clay. Yet, he continued to paint to the end of his life, with brushes taped to his wrists. To overcome these daunting obstacles, Renoir had his assistant, Guino, a young Spaniard who had studied with Aristide Maillol, create the models from Renoir's drawings, while Renoir supervised, pointing with a stick at places that needed alteration. The sculpture clearly translates Renoir's aesthetic into three dimensions in spite of the very significant participation of another pair of hands.

Mother and Child, 1916
Bronze
21 ½ x 8 x 8 ½ inches
(54.6 x 20.3 x 21.6 cm)
Acquired 1940

Auguste Rodin

b. 1840, Paris, d. 1917, Meudon, France

Because Duncan Phillips overwhelmingly preferred painting, there are very few sculptures in The Phillips Collection. Yet, he undoubtedly recognized the importance and achievement of Rodin, remarking that "[while] most sculpture is abstract and static, Rodin's is concrete and dynamic." However, it is also likely that he would have found the naturalistic sexuality of much of Rodin's work disconcerting. Phillips did not, in any event, buy *Brother and Sister*. It was one of seventeen works he chose from a list of forty-two offered to him by Marcel Duchamp, who was acting as executor of the estate of Katherine S. Dreier, another pioneer collector of modern art. The subject matter of

Brother and Sister made it easy for Phillips to assimilate an example of Rodin's animated bronze flesh into his collection. In *Brother and Sister*, the sculptor seems to suggest a maternal relationship between the siblings, rendering them as a much older sister, nude and slightly gawky, holding her squirmy little brother on her knees. Rodin endlessly reused figures, working out variations on them. Here, the sister echoes a sculpture Rodin made of the Greek sea-nymph Galatea. An example of the sculptor's late work, *Brother and Sister* enjoyed great popularity in France. More than twenty casts of it are known, of which Dreier said that the sculptor considered hers the best.

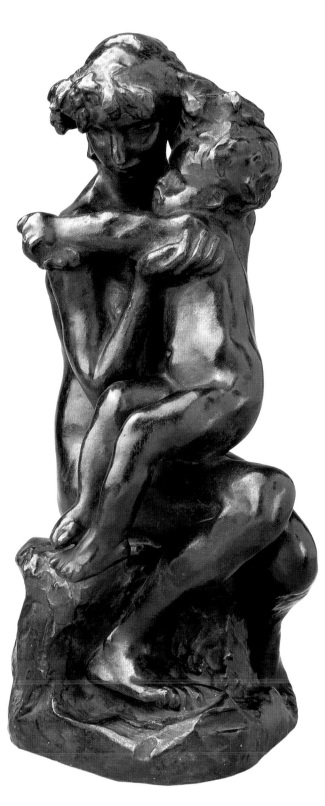

Brother and Sister, 1890
Bronze
15 x 7 x 6 ¼ inches
(38.1 x 17.7 x 15.8 cm)
Gift from the estate of Katherine S. Dreier, 1953

Henri Rousseau

b. 1844, Laval, France, d. 1910, Paris

Nicknamed Douanier, Rousseau was not, in fact, a customs inspector as is popularly believed, but a *gabelou*, a lowly collector in the municipal toll service. From 1872 Rousseau became a Sunday painter, completely self-taught, although along the way some well-known academic painters gave him pointers. His first works date from 1877. The official Salon did not accept Rousseau's works for exhibition, so from 1886 he showed with the Société des artistes indépendants. Rousseau retired from his job in 1893 to paint full time, living in desperate poverty on his tiny pension and earning extra money by giving music and art lessons. Even when dealers started buying his works at the very end of his life, his financial situation remained dire. Yet, these hard circumstances did not cow Rousseau. He took himself seriously as a painter, refusing to return an official decoration sent to him in error by the French government and using it for self-promotion. There was something magically irrepressible about Rousseau's naiveté, dignified self-confidence, and generosity. Young members of the avant-garde took him up. For example, Pablo Picasso gave a big party in his honor, Robert and Sonia Delaunay bought examples of his work (including The Phillips Collection's *Notre Dame*), and the poet and critic Guillaume Apollinaire defended him against critical ridicule. Rousseau's paintings won the admiration of artists belonging to the Blaue Reiter group, who also liked folk art. Characteristically, Rousseau accepted the avant-garde's promotion of him at face value.

Notre Dame dates to the year before Rousseau's death. Its simple composition, slightly askew perspective, and clear and beautiful colors are typical of his late work. The high finish of the painting recalls the artist's aspirations to Salon-style academicism. Characteristic, too, is the painting's introspective, dreamlike quality. Here, he captures the melancholy of Paris at twilight as a solitary figure, perhaps the painter himself, looks over the Seine from one of the quays towards Notre Dame. Duncan Phillips recognized in the painting Rousseau's instinctive sense of design and color harmony and bought it at a time when he had an interest in folk art.

Notre Dame, 1909
Oil on canvas
12 ⁷/₈ x 16 ¹/₈ inches
(32.7 x 40.9 cm)
Acquired 1930

Alfred Sisley

b. 1839, Paris, d. 1899, Moret-sur-Loing, France

Sisley's fuzzy, impressionist brushstrokes perfectly correspond to the dense atmospheric conditions of *Snow at Louveciennes*. In it, the snow continues to sift down, blurring edges, muffling forms, and muting colors along the chemin de l'Etarché, the lane behind Sisley's house, seen here from the artist's first-floor balcony. Confirming reports of heavy snowfalls in December 1874, the snow seems to be several inches deep on top of the wall along the lane and on surrounding rooftops. In the bare trees, the snow appears as a smoky haze. The painting's emphatic composition, rare in Sisley's oeuvre, highlights the contrast between the built and the natural world. One feels sympathy for the solitary, small, dark figure out in her apron, making her way through the snow, her black umbrella held at an angle against the weather. In the diffused light, there are no shadows. Instead, light bounces between the white surfaces of falling snowflakes and fallen snow, reflecting all nearby colors. Sisley faithfully records in his broken whites the muted echoes of the painting's keynote colors, the cool blue-green and the warm rust of the gates at the center of the composition.

Snow at Louveciennes was the third composition by Sisley that Duncan Phillips bought and the only one he kept. He regarded the painter as a genius, a "landscape painter of the first rank," and saw in his work a connection to English poetry. Of *Snow at Louveciennes* Phillips wrote that it was "a lyric of winter, enchanting both in its mood and in its tonality of tenderly transcribed 'values'."

Snow at Louveciennes, 1874
Oil on canvas
22 x 18 inches
(55.9 x 45.7 cm)
Acquired 1923

Vincent van Gogh

b. 1853, Groot Zundert, The Netherlands, d. 1890, Auvers-sur-Oise, France

All three paintings by van Gogh in The Phillips Collection date from the period of his greatest achievements, the last two years of his life. After two years in Paris, where he associated with the impressionists and met Paul Gauguin, van Gogh left in February 1888 for Arles, in search of a quieter life and with dreams of founding a community of artists under the leadership of Gauguin. After some months in Arles, van Gogh rented a small house on place Lamartine to be the home of his new community. Across the street from the so-called Yellow House was the public garden. *Entrance to the Public Gardens in Arles* dates between August and October 1888 when van Gogh was waiting eagerly for the arrival of Gauguin and for the start of their artistic collaboration. It was a period of great activity for van Gogh, as he worked at paintings intended as decorations for the Yellow House. Among them were paintings he made of the public gardens. Some of these, the Poet's Garden series, were intended for Gauguin's bedroom. They contained symbolic references to the collaborative relationship that van Gogh hoped to have with Gauguin. Other views of the gardens showed their more prosaic aspects. *Entrance to the Public Gardens in Arles* is thought to be one of these, and the entrance shown is thought to be the one more or less opposite the artist's home. The figure wearing a straw hat recurs in a number of paintings van Gogh produced during this period and may be a self-portrait. In van Gogh's mind, as he dreamed about the artistic life he intended to lead in the south of France, there were associations between Arles and Japan, and Arles and Honoré Daumier, and Daumier and Japanese art. Van Gogh's

Entrance to the Public Gardens in Arles, 1888
Oil on canvas
28 1/2 x 35 3/4 inches
(72.3 x 90.8 cm)
Acquired 1930

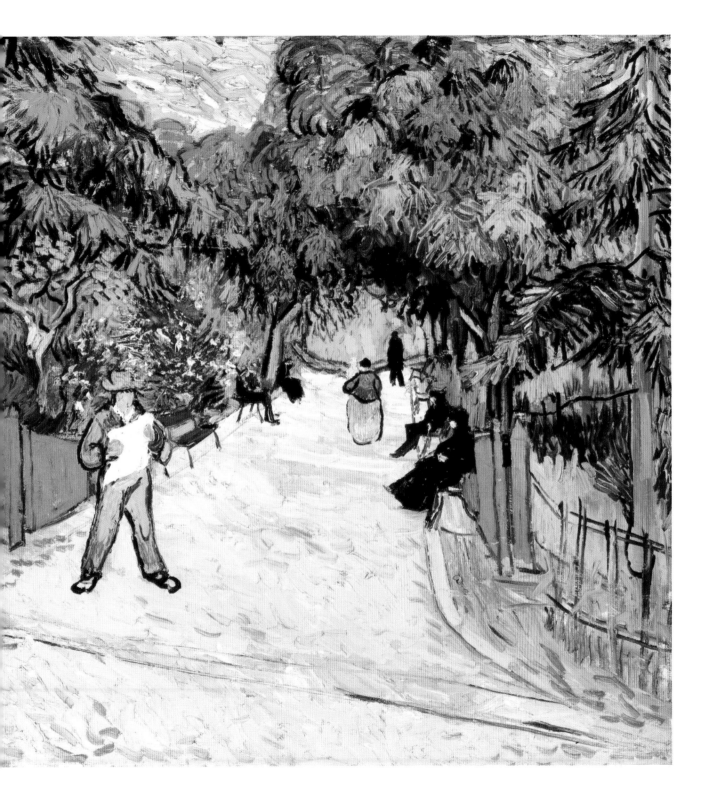

decorations for the Yellow House included Japanese woodcuts and prints by Daumier. Their influence can be seen in *Entrance to the Public Gardens in Arles*, where the treatment of the foliage recalls that found in Japanese prints, while the people recall both Japanese figures and those of Daumier.

Gauguin arrived in Arles in October 1888, living and working with van Gogh at the Yellow House until the end of December. He left two days after van Gogh sliced off his own ear, which led to the Dutch artist's confinement in a mental hospital at Saint-Rémy. On excursions from the hospital in the fall and winter of 1889–90, van Gogh witnessed the cours de l'Est (later renamed boulevard Mirabeau) in Saint-Rémy, being repaired. This inspired two versions of *The Road Menders*. The Phillips Collection's version is the second of the two. Van Gogh painted it in the studio in December 1889, a year after his breakdown. When he was living in Holland, van Gogh had treated the same subject matter of landscapes with workers. Perhaps, he associated the theme of road repairs with his own recovery and renewed capacity to travel along the pilgrim's road of life. Working in a paler palette than he had used in Arles, van Gogh expressed a desire to "begin again with the simpler colors, the ochers for instance." The continued influence of Japanese art on van Gogh is apparent in the painting's diagonal composition and in the patterned texture of the trees, among other elements.

In May 1890, van Gogh moved to Auvers-sur-Oise, near Paris, partly because he wanted to go north and partly in order to be near Dr. Paul-Ferdinand Gachet, a physician and amateur

The Road Menders, 1889
Oil on canvas
29 x 36 ½ inches
(73.7 x 92.8 cm)
Acquired 1949

House at Auvers, 1890
Oil on canvas
19 ⅛ x 24 ¾ inches
(48.5 x 62.8 cm)
Acquired 1952

artist, recommended to him as someone who might be able to help him. In the ten weeks van Gogh spent in Auvers before his death, his output was prodigious. *House at Auvers* was one of the paintings he did there. Van Gogh painted it six weeks before his suicide. He described it in a letter to his sister as "nothing but a green field of wheat stretching away to a white country house, surrounded by a white wall with a single tree." One of a number of paintings that he did of empty wheat fields, it has a claustrophobic quality that is not found in the thematically related open landscapes of the Dutch school. Its high horizon, flatness, and the patterned treatment of the wheat are further instances of Japanese art's influence on van Gogh.

Duncan Phillips's first response to the art of van Gogh was unfavorable. But, by 1926 he noted on his "wish list" his desire for examples of the artist's "inventive genius." Phillips considered van Gogh both "Japanese and Gothic" and made clear his appreciation of the artist's expressionism and palette. Phillips believed van Gogh, like Cézanne, to be a natural successor to El Greco and hung *Entrance to the Public Garden in Arles* with El Greco's *The Repentant St. Peter.*

Edouard Vuillard

b. 1868, Cuiseaux (Saône-et-Loire), France, d. 1940, La Baule, Brittany

Two chair backs and the edge of a tabletop in the foreground of Vuillard's *Interior* indicate that the setting is a dining room. The background wall, papered in a pattern of red and green flowers, is topped two-thirds of the way up by a grid of wooden moldings and panels suggestive of clerestory windows. At the far left, a door with a window panel stands open to a dark interior space with a shadowy figure. On the far right, within the compressed space, a woman wearing a blue striped dress stands bent over, her back to the viewer as though inspecting something. The room has been identified as the dining room in one of the apartments where Vuillard lived with his mother on rue Saint-Honoré in Paris. The figure may be the painter's mother, Mme Vuillard, who was a corset maker, bending over some sewing. Perhaps, the indistinct object seen against the wall behind one of the chairs is her sewing machine. But the objects themselves are not Vuillard's main concern. The true subject of the painting is the quiet atmosphere of a room in which a woman is at work. Significantly, in the journal Vuillard started as an art student, he noted his taste for the paintings of Jean-Siméon Chardin and Dutch seventeenth-century domestic interiors.

In 1889 Vuillard joined a small group of artists, including Ker-Xavier Roussel, Pierre Bonnard, Maurice Denis, Paul Sérusier, and Félix Vallotton, who called themselves the Nabis (prophets, in Hebrew) and believed in the decorative origins of art. In its composition, spatial ambiguity, color, and overall patterning, this tiny painting on cardboard reveals Vuillard's interest in Japanese art. It, like other Nabis work, shows a preference for simple outlines, flattened forms, and densely patterned surfaces, reflecting the influence of Ukiyo-e Japanese woodcuts as well as the symbolist paintings of Paul Gauguin. Vuillard started out painting small domestic interiors, as well as producing scenery, costume designs, and programs for symbolist theatrical productions that focused on the drama of inner life and on psychological tensions. The artist's small, private paintings explore similar terrain, conveying the atmosphere of daily life through muted colors and indefinite shapes, visual equivalents of silence.

Closely associated with *La revue blanche,* an art journal, Vuillard had his first one-person exhibition at its offices in 1891. He developed a friendship with the journal's editors, the Natansons, who gave him some important commissions. In 1899 Vuillard showed, for the first time, at the Bernheim-Jeune Gallery. Its director, Jos Hessel and his wife, Lucy, became patrons and friends. Through these connections, Vuillard's commissions increased. Working in an increasingly naturalistic style, Vuillard became well known as a society portraitist and painter of large-scale decorations, including murals, screens, and panels, intended for a well-off clientele.

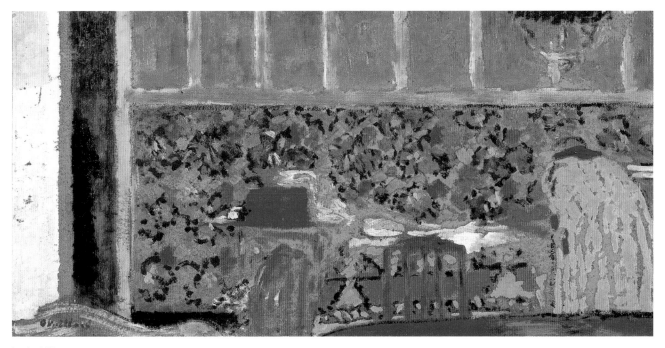

Interior, 1894
Oil on cardboard, mounted on canvas
10 ¹⁄₄ x 20 ¹⁄₈ inches
(26.1 x 51.1 cm)
Acquired 1954

Chronology

1886

June 26

Duncan Clinch Phillips, Jr., the second son of Major Duncan Clinch Phillips and Eliza Irwin Laughlin, is born in Pittsburgh, Pennsylvania. His older brother, James Laughlin, was born in 1884. Major Phillips had served as a volunteer in the Civil War, later becoming a manufacturer of window glass in Pittsburgh. Eliza's father, James Laughlin, was a banker and co-founder of the Jones and Laughlin Steel Co.

1895

Mrs. James Laughlin dies. Major and Mrs. Phillips spend the winter of 1895–96 in Washington and decide they prefer its climate to Pittsburgh's.

1897

Major Phillips buys property at Twenty-first and Q Streets, NW, and builds a house designed by Hornblower and Marshall.

1904

Duncan and Jim are enrolled at Yale University.

1905

Duncan publishes his first article, "At the Opposite Ends of Art" (*The Yale Literary Magazine* 70, June 1905).

1907

Duncan is elected an editor of *The Yale Literary Magazine*, serving 1907–08. He publishes article, "The Need of Art at Yale," in the June issue.

Hornblower and Marshall submit plans for the addition of a paneled library (now called the Music Room).

1908

Duncan and Jim graduate from Yale University.

1911

Summer

Duncan takes a trip to Europe; in Paris he visits the Louvre, the apartment of the great art dealer, Paul Durand-Ruel, and the Musée du Luxembourg.

1913

December

Duncan Phillips publishes a stinging review of the Armory Show, "Revolutions and Reactions in Painting" (*The International Studio*, 51 [December 1913]), calling it "stupefying in its vulgarity."

1914

While living in New York, Jim is the assistant director of the National Civic Federation, and Duncan publishes his first book, *The Enchantment of Art* (New York, 1914), a series of seventeen essays, including his 1913 review of the Armory Show. This essay is again reprinted in the 1927 edition of this book, but substantially changed and amended by a new foreword to reflect his more mature views: "Many of the ideas I was then eager to oppose I am now no less eager to uphold. To the charge of inconsistency I plead guilty, but it does not trouble my conscience. Consistency from youth to middle age is at best a stiff-necked virtue."

1916

January 6

Jim writes to his father about both brothers' enthusiasm for paintings and for collecting; he requests a yearly stipend for art purchases. A fund is duly established, and many of the early acquisitions are made by Jim as well as Duncan.

1917

September 13

Major Phillips dies suddenly.

Upon the United States' entry into the First World War, Duncan volunteers for service, is rejected for health reasons, and decides to join the Division of Pictorial Publicity, charged with inspiring artists to produce images of war. Slides are made, lectures prepared, and plans laid for the Allied War Salon (December 9–24, 1918), exhibition held at the American Art Galleries, New York.

1918

October 21

James Laughlin Phillips dies of Spanish flu in Washington, thirteen months after his father's death.

Duncan and his mother decide to found the Phillips Memorial Art Gallery, and Duncan begins to build a collection with this view. He makes numerous purchases so that, by June 1921, he publishes a checklist of the collection comprising some 230 titles. A handwritten note lists his "15 best purchases of 1918–19," including one work by Twachtman, two each by Monet and Weir, and Chardin's *A Bowl of Plums* (ca. 1728).

1920

March 3–31

The Corcoran Gallery of Art opens "Exhibition of Selected Paintings from the Collections of Mrs. D. C. Phillips and Mr. Duncan Phillips of Washington." On view are sixty-two works.

May

McKim, Mead & White design a second skylit story over the north wing of 1600 Twenty-first Street. This addition becomes the Main Gallery once the museum opens.

July 23

The Phillips Memorial Art Gallery is incorporated. Phillips later wrote about his aims for the museum: "The idea to which this unique collection is consecrated is that of a dual function and purpose: the concept of a small intimate museum of the world's best art combined with an experiment station where living and constantly developing artists can show the results of their research and their aesthetic adventures."

November 20–December 20

Phillips lends forty-three paintings to the Century Club in New York. The exhibition is called "Selected Paintings from the Phillips Memorial Art Gallery." Shown are works by Monet, Daumier, Ryder, Twachtman, and Weir.

Marjorie Acker, a young artist, visits the exhibition and is deeply impressed by Phillips. Born in Bourbon, Indiana, on October 25, 1894, Marjorie began her studies in 1914 at the

Art Students League, New York. Her first exhibition is held at Kraushaar Galleries, New York, in 1923.

1921
May
Marjorie Acker and the Gifford Bealses visit the Phillipses' house in Washington and see the Main Gallery and North Library hung with paintings.

October 8
Duncan Phillips and Marjorie Acker are married in Ossining, New York.

Late fall
The Gallery quietly opens to the public; it is the beginning of the first museum of modern art in America.

Phillips is working on the introductions to the first two books of a projected series entitled Phillips Collection Publications. At the same time he elaborates on his idea for an annual publication, *The Herald of Art*.

1922
January 3
Phillips writes letters to the three leading Washington newspapers announcing the new season. The Gallery is named the Phillips Memorial Art Gallery for only about one year before being renamed the Phillips Memorial Gallery. In October 1948 it becomes formally known as The Phillips Gallery, finally to be called The Phillips Collection in July 1961. The first two Phillips Collection Publications appear in rapid succession. The first is a collection of essays, *Julian Alden Weir* (New York, 1922), and the other a work entitled *Honoré Daumier, Appreciations of His Life and Works* (New York, 1922).

February 15
William Mitchell Kendall, of McKim, Mead & White, and head of the Gallery's committee on architecture, submits the committee's recommendations for a new museum to be built in Washington. The museum is never built; instead, the family later moves to a new residence, leaving the existing building for the collection.

July 10
Daughter Mary Marjorie is born in New York.

November
In a press release sent to *The Evening Star*, Phillips announces the fall exhibition of the Phillips Memorial Art Gallery—thirty-one works highlighting major new acquisitions.

1923
June 6
Duncan and Marjorie Phillips sail from New York for a two-month stay in Europe. During lunch at the Joseph Durand-Ruels, they see Renoir's *Luncheon of the Boating Party*. They decide to buy the painting, which is sent to the United States later that year.

December

The fall season of 1923 opens with a changed gallery hanging of the permanent collection, including the newly acquired Renoir.

1924

March 26–April 26

The Phillips Memorial Gallery opens "Exhibition of Recent Decorative Paintings by Augustus Vincent Tack." The sixteen works represent the first museum showing for this artist, who was a fellow member of the Century Club and Phillips's friend from his days in New York.

Phillips sees Pierre Bonnard's painting, *Woman with Dog* (1922), at the Carnegie International Exhibition in Pittsburgh and purchases it the following year—the first of sixteen paintings by Bonnard to enter the collection.

October 20

Son Laughlin Phillips is born in Washington. Later a Foreign Service officer and then a publisher, Laughlin Phillips serves as The Phillips Collection's director from 1972 to 1992.

1925

In early January Phillips inaugurates a series of small one-artist exhibitions in the newly opened Little Gallery. Opening with ten recent works by Marjorie Phillips, the gallery is henceforth used to focus on the work of American artists. The Main Gallery, meanwhile, continues to feature newly acquired works by European and American masters.

February 15

The Sunday Star announces that the Phillips Memorial Gallery has purchased *The Uprising* (ca. 1848) by Honoré Daumier.

1926

January 11–February 7

An exhibition of work by Arthur Dove is held at Alfred Stieglitz's Intimate Gallery in New York. Phillips buys his first two paintings by Dove, *Golden Storm* (1925) and *Waterfall* (1925)**,** and includes them in his own "Exhibition of Paintings by Eleven Americans and an Important Work by Odilon Redon," opening in February. He eventually purchases more than forty-eight works by Dove.

Duncan Phillips's book, *A Collection in the Making* (New York and Washington D.C., 1926) is published.

September

The Phillipses meet Bonnard, who visits the Gallery while in the United States as a juror for the Carnegie International Exhibition.

1927

January 15

Phillips writes to Alfred Barr (soon to be the first director of the Museum of Modern Art in New York) about showing several works by John Marin: "In February and March I will give Washington a bracing shock in the work of this stimulating creator, with his incisive brain, his flashing eye, his startling intuition and magic with his medium."

February 5 through April
The museum presents the first of five Tri-Unit Exhibitions (two installations follow in 1928–29, with two final exhibitions in 1929–30).

1928
March 6–31
"Exhibition of Paintings by John Graham."

November. The Art Gallery of Toronto presents "An Exhibition of Paintings Lent by the Phillips Memorial Gallery, Washington: French Paintings from Daumier to Derain and Contemporary American Paintings."

1929
February 2
An exhibition of watercolors by Marin is installed in the Little Gallery. In the Lower Gallery, "A Retrospective Exhibition of Paintings by Arthur B. Davies."

October 25
Phillips is elected to the board of trustees of the Museum of Modern Art, New York.

C. Law Watkins, an artist, and former Yale classmate and friend of Duncan Phillips, becomes Associate Director in Charge of Education. He gives free lessons in painting at the Gallery, and the classes grow from a handful of students in 1929 to an enrollment of approximately 200 pupils by 1931.

November
The first of a projected series of journals, *Art and Understanding* is published by the Phillips Memorial Gallery.

December
"An Exhibition of Recent Paintings by Karl Knaths." Phillips bought his first painting by Knaths in 1926, eventually accumulating the largest museum collection of works by the artist. The relationship of artist and patron soon grew into a lasting friendship, and Knaths joined the faculty of the art school as a guest instructor in 1938.

By 1930, Phillips begins to refer to the Phillips Memorial Gallery as "a museum of modern art and its sources."

1930
With Stieglitz acting as intermediary, Phillips begins paying Dove a monthly stipend in return for first choice of paintings from the annual Dove exhibition organized by Stieglitz. Although he carried on an active correspondence with Dove and remained his most faithful supporter, Phillips met the artist only once, in the spring of 1936.

March
The second volume of *Art and Understanding* is published.

May
J. B. Neumann, a New York gallery owner, sends three paintings by Paul Klee on approval. Phillips purchases *Tree Nursery*, the first of thirteen paintings by Klee to enter the collection.

Fall
The Phillips family moves to a new house at 2101 Foxhall Road. "Dunmarlin" (for Duncan, Marjorie, and Laughlin) was designed by the

architect Nathan Wyeth. Phillips and Watkins work on the conversion of the former residence into galleries, offices, and storage space.

September 26
Henri Matisse, a member of the European jury of the Carnegie International Exhibition, visits the Phillips Memorial Gallery.

October 5, 1930–January 25, 1931
To celebrate the new season, Phillips installs eight exhibitions and gallery hangings. In subsequent seasons he continues his practice of interpreting the works from his collection through changing gallery hangings.

1931
March 20
Phillips delivers the Trowbridge Lecture, "The Artist Sees Differently," at Yale University. The concepts developed in this popular lecture form the nucleus of the book *The Artist Sees Differently: Essays Based Upon the Philosophy of the Collection in the Making* (New York, 1931).

1932
February
"Daumier and Ryder" and "American and European Abstractions" open at the Phillips Memorial Gallery. Included are four paintings by Dove, two each by Georges Braque and Pablo Picasso, and one painting each by Juan Gris and Knaths.
The Phillipses, accompanied by their son Laughlin, embark on the first of three "Giorgione trips" as part of Phillips's research on the artist, which eventually leads to a publication in 1937.

June
Phillips writes his first letter to Bernard Berenson, a correspondence that lasts for several years and deals with issues of attribution and interpretation of works by Giorgione.

October 19
Phillips writes a letter declining the request of the Yale University Art Gallery to give the entire Phillips Collection to Yale.

Fall
The Phillips Gallery Art School closes through the summer of 1933 due to the Depression; the Gallery is open only Saturdays from 11 a.m. to 6 p.m. Its full schedule only resumes in October 1933.

1932–33
Phillips is chairman of the Regional Committee No. 4, Public Works of Art Project. Artists are commissioned to paint murals and easel paintings representing "The American Scene."

1933
October 14–November 15
Studio House, a combination sales gallery and art school established by Watkins, opens its doors at 1614 Twenty-first Street, NW, with "Opening Exhibition of Recent American Painting." Art classes previously conducted at the museum move to Studio House and are expanded to life classes, anatomy classes, and advanced courses in painting. Conferences on comparative criticism are conducted at the Gallery under the guidance of Phillips.

November 5, 1933–February 15, 1934
The exhibition "Freshness of Vision in Painting" features a rehanging of all galleries. Included are: "Pictures of People," an exhibition installed in three galleries; works by Louis Eilshemius and Charles Burchfield hung in two separate galleries; a theme exhibition "Classic and Romantic"; and other paintings gathered under the subject "Modern Idioms—Lyrical and Impersonal."

1934
The first annual "Exhibition of Paintings and Drawings by Students of the Phillips Memorial Art School and of Artists Associated with Studio House" is held at Studio House. These exhibitions continue until 1938.

December 29
Gertrude Stein delivers her lecture "Pictures" at the Phillips Memorial Gallery.

1935
November
Phillips delivers an address on the Public Works of Art Project, pleading for extension of the program and continued funding.

1937
Beginning with the 1937–38 season, the exhibition program at the Phillips Memorial Gallery becomes very active. Eighteen exhibitions are installed in all galleries and special drawing shows are presented in the Print Rooms.

March 23–April 18
The Gallery presents "Retrospective Exhibition of Works in Various Media by Arthur G. Dove." This exhibition of fifty-seven works is Dove's first major retrospective at the Gallery and the only one during the artist's lifetime.

Phillips publishes *The Leadership of Giorgione* (Washington, D.C., 1937).

1938
March 10
The Print Rooms feature a small exhibition from the permanent collection, supplemented by loans, "An Exhibition of Watercolors and Oils by Paul Klee."

Fall
Studio House closes permanently. The Phillips Gallery Art School moves to the top floor of the Phillips Memorial Gallery. The staff remains the same, but the exhibition program is discontinued.

1939
January 1–20
"Toulouse-Lautrec: Exhibition of Drawings, Lithographs, Posters" is held in the Print Rooms.

By 1939, the exhibition program has increased to twenty-five separate exhibitions and gallery hangings, among them nineteen paintings by Edouard Vuillard and portraits by Watkins.

1940
Phillips becomes a trustee and member of the acquisition committee of the National Gallery of Art.

April 7–May 5
Watkins develops his first educational exhibition, "Emotional Design in Painting," presenting seventy-two works grouped under twenty-eight motifs and design concepts. Works by old masters on loan from museums nationwide are hung with contemporary works in a didactic sequence, exploring the expressive function of diagonals, organic forms, motion, and shape.

December 15
"Georges Rouault: Retrospective Loan Exhibition" opens at the Gallery.

1941
The Museum of Modern Art, New York, receives a painting, Dove's *Willows* (1940), as a gift from Phillips.

June
Phillips buys a painting by Honoré Daumier as a gift for the National Gallery of Art.

1942
From about January to September 26, 1944, during the period of possible air raids, thirty-three works from the Phillips Memorial Gallery go to the Colorado Springs Fine Arts Center for safe exhibition and storage. Other works go to the William Rockhill Nelson Gallery of Art in Kansas City, where they are exhibited for approximately the same amount of time.

February 14–March 3
The Phillips Memorial Gallery is the first museum to exhibit Jacob Lawrence's series The Migration of the Negro in an exhibition entitled "And the Migrants Kept Coming." At the end of this show, Duncan Phillips purchases the thirty odd-numbered panels. The even-numbered ones enter the collection of the Museum of Modern Art, which from 1942 to 1944 circulates the entire series on a nationwide tour.

Spring
Phillips purchases his first two works by Morris Graves, eventually developing a Graves Unit.

June
"Paul Klee: A Memorial Exhibition" opens.

1943
During the spring and fall seasons the gallery presents twenty-nine exhibitions, among them numerous one-artist exhibitions showing the work of Milton Avery, Augustus Vincent Tack, and Dove as well as several exhibitions of drawings, photographs, and students' work.

August 1–September 30
"John Marin: A Retrospective Loan Exhibition of Paintings," organized by the Phillips Memorial Gallery, features twenty works.

1945
January 14–February 26
The exhibition "Eugène Delacroix: A Loan Exhibition" presents thirteen works from Wildenstein Galleries, New York.

October 21–November 17
"A Loan Exhibition of Fifty-Two Drawings for Ariosto's 'Orlando Furioso' by Fragonard" is

shown in the Print Rooms. Phillips purchases two drawings, No. 93 and No. 110, for the collection.

1946
November 3–24
The Phillips Memorial Gallery shows "Pioneers of Modern Art in America," a traveling exhibition of sixty-four works, circulated by the American Federation of Arts.

November 22
Arthur Dove dies in Huntington, Long Island. In October he had written his last letter to Duncan and Marjorie Phillips:
"After fighting for an idea all your life I realize that your backing has saved it for me and I meant to thank you with all my heart and soul for what you have done."

1947
March 30–April 30
"Loan Exhibition of Drawings and Pastels by Edgar Degas," an exhibition of thirty-six works, is shown in the Print Rooms.

April 18–September 22.
"A Retrospective Exhibition of Paintings by Arthur G. Dove." In the course of the year Phillips buys three watercolors and two paintings by Dove from the Downtown Gallery, increasing the Dove Unit to more than forty works.

1948
October 17–November 7
"Sixty Drawings by Matisse," a selection from a large drawing exhibition held in Philadelphia, is shown in the Print Rooms and subsequently circulated by the American Federation of Arts.

December 7, 1948–January 17, 1949
"Oskar Kokoschka: A Retrospective Exhibition," organized and circulated by the Institute of Contemporary Art, Boston, is held at the Gallery. On view are 126 works. The artist visits Washington on January 11 and lectures on his work.

1949
March 24–May 2
"Paintings, Drawings, and Prints by Paul Klee from the Klee Foundation, Berne, Switzerland, with Additions from American Collections." The exhibition, comprising 202 works, includes a major loan from the foundation's holdings, never before exhibited in the United States. Five paintings from The Phillips Gallery are lent to this exhibition.

May 8–June 9
A loan exhibition of thirty-one works, "Paintings by Grandma Moses," is shown in the Print Rooms. Phillips purchases the painting *Hoosick Falls in Winter* (1944).

Phillips writes an article, "Pierre Bonnard" (*The Kenyon Review,* 11, [Autumn 1949]).

November 6–29
Alfred Stieglitz's Equivalents series is exhibited in the Print Rooms.

1950
May 28–June 20
A traveling exhibition, "Edvard Munch," organized by the Institute of Contemporary Art, Boston, opens at The Phillips Gallery. Included are 171 paintings.

June 25–September 16
Phillips installs nine works by Augustus Vincent Tack in the Main Gallery for the "Memorial Exhibition: Abstractions by A. V. Tack." The artist had died on June 21, 1949.

1952
March 29
Katherine S. Dreier dies, leaving part of her private collection to be dispersed by her executors. On May 7, Marcel Duchamp announces his visit to Washington, and upon arriving, he informs Phillips of the executors' decision to make a major bequest to The Phillips Gallery. Phillips chooses seventeen works, including major paintings by Braque, Klee, Mondrian, and Kandinsky. At Phillips's suggestion, fourteen works from the Dreier Bequest are sent to the fledgling Watkins Gallery at the American University.

1952
The first comprehensive catalogue of the collection is published, *The Phillips Collection: A Museum of Modern Art and Its Sources* (New York and London, 1952).

November
Phillips gives a painting by Edgar Degas, *Ballet Rehearsal* (ca. 1885), to the Yale University Art Gallery on the occasion of the laying of the cornerstone for the new gallery.

1956
May 23–June 4
"Paintings by Nicolas de Staël," an exhibition circulated by the American Federation of Arts, is shown at the Gallery. In 1950 Phillips had bought *North* (1949), the first work by this artist to be acquired by an American museum. During the early 1950s, Phillips had established a de Staël Unit, a representative block of works that offers a survey of the artist's stylistic development.

1957
January–February 26
A small exhibition entitled "Paintings by Tomlin, Rothko, Okada," is held in the Print Rooms, the first showing of Rothko's work at the Gallery.

1959

April 24

As part of its fiftieth anniversary, the American Federation of Arts makes awards for outstanding contribution to art and artists in America. Honorees are Duncan Phillips, Robert Woods Bliss, Alfred Barr, and Paul J. Sachs.

1960

November 5

The new wing of the museum opens to the public. The Braque Unit is displayed downstairs, and a small room is designated to display the three paintings by Mark Rothko now in the collection. A fourth painting is added to the Rothko Room in 1964. Marjorie Phillips recalls in her book that "Duncan derived untold pleasure from this room."

1961

Phillips continues his practice of introducing the work of contemporary artists in small, one-artist exhibitions in the Print Rooms.

March 12–April 12. "Vieira da Silva," includes twenty-five works, and *Easels* (1961) is purchased for the collection.

May 19–June 26

A loan exhibition, "Richard Diebenkorn," also shown in the Print Rooms, includes eighteen works.

July

The museum's name is officially changed to The Phillips Collection.

1962

January 28–February 28

"Paintings by Josef Albers," a loan exhibition of twenty works, is installed in the Print Rooms.

March 11–April 30

With the showing of "David Smith," organized by the Museum of Modern Art in New York, The Phillips Collection begins a series of large, important sculpture exhibitions.

May 6–July 1

The entire museum is given over to an exhibition of the work of Mark Tobey. Organized by The Phillips Collection, the loan exhibition presents forty-five works dating from 1935 to 1961.

1963

February 7–May 18
The Phillips Collection presents "Giacometti," an exhibition of thirty-seven sculptures. *Monumental Head* (1960) is purchased for the collection.

1964

For the spring and fall seasons, the museum embarks on an active program of exhibitions. As has been his practice since the early days of the Gallery, Phillips purchases one or more works from most exhibitions while, at the same time, adding the works of younger artists to his "Encouragement Collection." Exhibitions include:

January 12–February 24
"Seymour Lipton."

March 14–April 16
"Manessier."

October 3–November 17
 "The Cubist Period of Jacques Lipchitz."

November 14–December 27. "Etienne Hajdu."

1966

April 9–May 30
The Phillips Collection installs an exhibition of thirty-six works, "Paintings by Arthur G. Dove from the Collection."

May 9
Shortly after having supervised the installation of the Dove exhibition, Duncan Phillips falls ill and dies at his home in Washington.

* * *

After the death of Duncan Phillips, Marjorie Phillips served as director of The Phillips Collection. Their son, Laughlin, became director in 1972, after her retirement. Marjorie Phillips died in 1985. In 1988 the museum's Annex closed for renovation and expansion. It reopened in fall 1989 as the Goh Annex.

Excerpted from the chronology by Erika Passantino and Sarah Martin in *Duncan Phillips Centennial Exhibition*, exhibition catalogue, Washington, D.C., The Phillips Collection, 1986.

Checklist

Pierre Bonnard (1867–1947)
Woman with Dog
1922
Oil on canvas
27 ¼ x 15 ⅜ inches (69.1 x 39 cm)
Acquired 1925

The Palm
1926
Oil on canvas
45 x 57 ⅞ inches (114.3 x 147 cm)
Acquired 1928

Georges Braque (1882–1963)
Still Life with Grapes and Clarinet
1927
Oil on canvas
21 ¼ x 28 ¾ inches (53.9 x 73 cm)
Acquired 1929

Lemons and Napkin Ring
1928
Oil and graphite on canvas
15 ¾ x 47 ¼ inches (40 x 120 cm)
Acquired 1931

The Round Table
1929
Oil, sand, and charcoal on canvas
57 ⅜ x 44 ¾ inches (145.6 x 113.8 cm)
Acquired 1934

Paul Cézanne (1839–1906)
Self-Portrait
1878–80
Oil on canvas
23 ¾ x 18 ½ inches (60.4 x 47 cm)
Acquired 1928

Mont Sainte-Victoire
1886–87
Oil on canvas
23 ½ x 28 ½ inches (59.6 x 72.3 cm)
Acquired 1925

Ginger Pot with Pomegranate and Pears
1890–93
Oil on canvas
18 ¼ x 21 ⅞ inches (46.4 x 55.6 cm)
Gift of Gifford Phillips in memory of his father,
James Laughlin Phillips, 1939

Seated Woman in Blue
1902–04
Oil on canvas
26 x 19 ¾ inches (66 x 50.1 cm)
Acquired 1946

The Garden at Les Lauves
ca. 1906
Oil on canvas
25 ¾ x 31 ⅞ inches (65.4 x 80.9 cm)
Acquired 1955

Jean-Siméon Chardin (1699–1779)

A Bowl of Plums
ca. 1728
Oil on canvas
17 ½ x 22 ⅛ inches (44.6 x 56.3 cm)
Acquired 1920

John Constable (1776–1837)

On the River Stour
ca. 1834–37
Oil on canvas
24 x 31 inches (61 x 78.6 cm)
Acquired 1925

Jean-Baptiste-Camille Corot (1796–1875)

Civita Castellana
1826 or 1827
Oil on paper
8 ⅞ x 14 inches (22.6 x 35.6 cm)
Acquired 1946

View from the Farnese Gardens, Rome
1826
Oil on paper, mounted on canvas
9 ⅝ x 15 ¾ inches (24.5 x 40.1 cm)
Acquired 1942

Genzano
1843
Oil on canvas
14 ⅛ x 22 ½ inches (35.8 x 57.1 cm)
Acquired 1955

Gustave Courbet (1819–77)

Rocks at Mouthier
ca. 1855
Oil on canvas
29 ¾ x 46 inches (75.5 x 116.8 cm)
Acquired 1925

The Mediterranean
1857
Oil on canvas
23 ¼ x 33 ½ inches (59 x 85.1 cm)
Acquired 1924

Honoré Daumier (1808–79)

The Uprising
1848 or later
Oil on canvas
34 ½ x 44 ½ inches (87.6 x 113 cm)
Acquired 1925

Three Lawyers
1855–57
Oil on canvas
16 x 12 ¾ inches (40.7 x 32.4 cm)
Acquired 1920

The Strong Man
ca. 1865
Oil on wood panel
10 ⅝ x 13 ⅞ inches (27 x 35.2 cm)
Acquired 1928

Hilaire-Germain-Edgar Degas (1834–1917)
Melancholy
late 1860s
Oil on canvas
7 ½ x 9 ¾ inches (19 x 24.7 cm)
Acquired 1941

Women Combing Their Hair
ca. 1875–76
Oil on paper, mounted on canvas
12 ¾ x 18 ⅛ inches (32.4 x 46.2 cm)
Acquired 1940

Dancers at the Bar
ca. 1900
Oil on canvas
51 ¼ x 38 ½ inches (130.1 x 97.7 cm)
Acquired 1944

**Ferdinand-Victor-Eugène Delacroix
(1798–1863)**
Paganini
1831
Oil on cardboard, on wood panel
17 ⅝ x 11 ⅞ inches (44.7 x 30.1 cm)
Acquired 1922

Horses Coming Out of the Sea
1860
Oil on canvas
20 ¼ x 24 ¼ inches (51.4 x 61.5 cm)
Acquired 1945

Raoul Dufy (1877–1953)
The Opera, Paris
early 1930s
Gouache on paper
19 ¾ x 25 ¼ inches (50.2 x 64 cm)
Acquired 1939

The Artist's Studio
1935
Oil on canvas
47 x 58 ⅞ inches (119.4 x 149.6 cm)
Acquired 1944

Paul Gauguin (1848–1903)
The Ham
1889
Oil on canvas
19 ¾ x 22 ¾ inches (50.2 x 57.8 cm)
Acquired 1951

Alberto Giacometti (1901–66)
Monumental Head
1960
Bronze
37 ½ x 11 x 10 inches (95.2 x 27.9 x 25.4 cm)
Acquired 1962

Francisco José de Goya (1746–1828)
The Repentant St. Peter
ca. 1820–24
Oil on canvas
28 ¾ x 25 ¼ inches (73 x 64.2 cm)
Acquired 1936

El Greco (Domenikos Theotokopoulos)
(1541–1614)
The Repentant St. Peter
ca. 1600–05 or later
Oil on canvas
36 ⅞ x 29 ⅝ inches (93.7 x 75.2 cm)
Acquired 1922

Juan Gris (1887–1927)
Still Life with Newspaper
1916
Oil on canvas
29 x 23 ¾ inches (73.6 x 60.3 cm)
Acquired 1950

Jean-Auguste-Dominique Ingres (1780–1867)
The Small Bather
1826
Oil on canvas
12 ⅞ x 9 ⅞ inches (32.7 x 25 cm)
Acquired 1948

Wassily Kandinsky (1866–1944)
Autumn II
1912
Oil and oil washes on canvas
23 ⅞ x 32 ½ inches (60.5 x 82.5 cm)
Acquired 1945

Sketch I for Painting with White Border (Moscow)
1913
Oil on canvas
39 ⅜ x 30 ⅞ inches (100 x 78.3 cm)
Gift from the estate of Katherine S. Dreier, 1953

Paul Klee (1879–1940)
Cathedral
1924
Watercolor and oil washes on paper,
mounted on cardboard and wood panel
11 ⅞ x 14 inches (30.1 x 35.5 cm)
Acquired 1942

Arab Song
1932
Oil on burlap
35 ⅞ x 25 ⅜ inches (91.1 x 64.5 cm)
Acquired 1940

Picture Album
1937
Oil on canvas
23 ⅝ x 22 ¼ inches (60 x 56.5 cm)
Acquired 1948

The Way to the Citadel
1937
Oil on canvas, mounted on cardboard
26 ⅜ x 22 ⅜ inches (67 x 56.8 cm)
Acquired 1940

Oskar Kokoschka (1886–1980)
Portrait of Lotte Franzos
1909
Oil on canvas
45 ¼ x 31 ¼ inches (114.9 x 79.5 cm)
Acquired 1941

Franz Marc (1880–1916)
Deer in the Forest I
1913
Oil on canvas
39 ¾ x 41 ¼ inches (100.9 x 104.7 cm)
Gift from the estate of Katherine S. Dreier, 1953

Henri Matisse (1869–1954)
Interior with Egyptian Curtain
1948
Oil on canvas
45 ¾ x 35 ⅛ inches (116.3 x 89.2 cm)
Acquired 1950

Claude Monet (1840–1926)
The Road to Vétheuil
1879
Oil on canvas
23 ⅜ x 28 ⅝ inches (59.4 x 72.7 cm)
Acquired 1920

Val-Saint-Nicolas, near Dieppe (Morning)
1897
Oil on canvas
25 ½ x 39 ⅜ inches (64.8 x 99.9 cm)
Acquired 1959

Berthe Morisot (1841–95)
Two Girls
ca. 1894
Oil on canvas
25 ⅝ x 21 ¼ inches (65 x 54 cm)
Acquired 1925

Pablo Picasso (1881–1973)
The Blue Room
1901
Oil on canvas
19 ⅞ x 24 ¼ inches (50.4 x 61.5 cm)
Acquired 1927

The Jester
1905
Bronze
16 ⅛ inches (40.9 cm)
Acquired 1938

Bullfight
1934
Oil on canvas
19 ⅝ x 25 ¾ inches (49.8 x 65.4 cm)
Acquired 1937

Pierre Puvis de Chavannes (1824–98)
Massilia, Greek Colony
ca. 1868–69
Oil on canvas
38 ⅞ x 57 ⅞ inches (98.9 x 147 cm)
Acquired 1923

Marseilles, Gateway to the Orient
ca. 1868–69
Oil on canvas
38 ¾ x 57 ⅝ inches (98.8 x 146.5 cm)
Acquired 1923

Odilon Redon (1840–1916)
Mystery
ca. 1910
Oil on canvas
28 ¾ x 21 ⅜ inches (73 x 54.3 cm)
Acquired 1925

Pierre-Auguste Renoir (1841–1919)
Luncheon of the Boating Party
1880–81
Oil on canvas
51 ¼ x 69 ⅛ inches (130.2 x 175.6 cm)
Acquired 1923

**Pierre-Auguste Renoir and Richard Guino
(1890–1973)**
Mother and Child
1916
Bronze
21 ½ x 8 x 8 ½ inches (54.6 x 20.3 x 21.6 cm)
Acquired 1940

Auguste Rodin (1840–1917)
Brother and Sister
1890
Bronze
15 x 7 x 6 ¼ inches (38.1 x 17.7 x 15.8 cm)
Gift from the estate of Katherine S. Dreier, 1953

Henri Rousseau (1844–1910)
Notre Dame
1909
Oil on canvas
12 ⅞ x 16 ⅛ inches (32.7 x 40.9 cm)
Acquired 1930

Alfred Sisley (1839–99)
Snow at Louveciennes
1874
Oil on canvas
22 x 18 inches (55.9 x 45.7 cm)
Acquired 1923

Vincent van Gogh (1853–90)
Entrance to the Public Gardens in Arles
1888
Oil on canvas
28 ½ x 35 ¾ inches (72.3 x 90.8 cm)
Acquired 1930

The Road Menders
1889
Oil on canvas
29 x 36 ½ inches (73.7 x 92.8 cm)
Acquired 1949

House at Auvers
1890
Oil on canvas
19 ⅛ x 24 ¾ inches (48.5 x 62.8 cm)
Acquired 1952

Edouard Vuillard (1868–1940)
Interior
1894
Oil on cardboard, mounted on canvas
10 ¼ x 20 ⅛ inches (26.1 x 51.1 cm)
Acquired 1954

References

Page 11

"Art offers two great gifts of emotion . . . "
Duncan Phillips, *A Collection in the Making*,
(New York and Washington, D.C., 1926), 3–4.

"A man may succeed in memorizing . . . "
Duncan Phillips, "The Need of Art at Yale,"
The Yale Literary Magazine, 72: 9 (June 1907), 356.

Page 12

"My own special function . . . ", Duncan Phillips,
"A Collection Still in the Making," in *The Artist
Sees Differently: Essays Based upon the Philosophy of
a Collection in the Making*, (New York and
Washington, D.C., 1931), 12.

Page 13

**"Instead of the academic grandeur of marble
halls . . . "** Phillips, *A Collection in the Making*, 5–6.

**"The possessor of one of the greatest paintings
in the world . . . "** Phillips, letter to Dwight Clark,
treasurer of the Phillips Memorial Gallery,
July 10, 1923.

"I could get lesser examples . . . " Phillips, letter
to Guy Pène du Bois at *International Studio*,
December 20, 1923.

Page 14

**"Daumier's *The Uprising* is not only one of the
greatest paintings . . . "** Duncan Phillips, The
Nation's Greatest Paintings: Honoré Daumier,
"The Uprising," New York, 1942.

"I avoid the usual period rooms . . . "
Phillips, *A Collection in the Making*, 6.

Page 16

"Mr. Holmes has risked a good deal . . . "
Roger Fry, "El Greco" (*Athenaeum*, 1920), in
Vision and Design, (London, 1920), 134. The
Museum of Fine Arts, Boston was the first
museum in the United States to acquire a
painting by El Greco, in 1904, a painting titled
Fray Hortensio Felix Paravicino (1609). The
following year (1905) the Metropolitan
Museum of Art, New York, acquired their first
painting by El Greco, *The Adoration of the
Shepherds* (ca.1610).

Page 17

"Art of building forms in space . . . " Duncan
Phillips, "El Greco – Cezanne – Picasso", *Art
and Understanding*, 1: 1 (November 1929), 102.

**"Cézanne would not have altogether
approved . . . "** *ibid*, 104.

Page 18

"In spite of the fact . . . " Duncan Phillips,
letter to Paul Rosenberg, October 18, 1951.
Gauguin's *Idyll of Tahiti* (present location
unknown) was traded to the Newhouse
Galleries in 1936 as partial payment for Goya's
The Repentant St. Peter.

**"Bonnard is the supreme sensitivity, the music-
maker of color . . . "** Duncan Phillips, *A Loan
Exhibition: Six Paintings by Bonnard*, exhibition
catalogue, Washington, D.C., The Phillips
Gallery, 1958.

Page 19
"No matter how original such great individualists as Bonnard and John Marin may be . . . "
Duncan Phillips, "Modern Art, 1930," *The Art News*, 28: 27 (April 5, 1930), 15. (Reprinted from the March issue of *Art and Understanding*).

"With those of us who pride ourselves on open-mindedness . . . " Phillips, *ibid*, 14–15.

Page 20
"first of all to establish a collection . . . "
Painting and Sculpture in the Museum of Modern Art, ed. Alfred H. Barr, Jr. (New York, 1948), 7.

Page 21
"preference to accept only such works as relate in one way or another to the wide scope and yet the very personal taste of my own Collection . . . " Phillips, letter to Marcel Duchamp, July 25, 1952.

Page 22
"Klee builds himself a little house of art . . . "
Phillips, transcript of a slide lecture, version E ("Expression of Personality"), ca. 1938–42.

Page 24
"Lived with, worked with, and loved . . . "
Phillips, transcript of a radio talk entitled "The Pleasures of an Intimate Art Gallery," Washington, D.C., WCFM, February 24, 1954.

"Pictures send us back to life . . . "
Phillips, *A Collection in the Making*, 1926, 5 quoted in "Duncan Phillips, Collector, Dies," *The New York Times*, May 11, 1966.

Page 28
Bonnard and The Phillips Collection, see *The Eye of Duncan Phillips: A Collection in the Making*, ed. Erika D. Passantino (New Haven and Washington, D.C., 1999), 190–199.

Page 32
"We must make [people] want to touch . . . "
quoted by Passantino, *ibid*, 248.

Page 42
"the color sensations which give us light . . . "
quoted by Passantino, *ibid*, 97.

Page 46
"There are generally in the life of an artist . . . "
quoted by Passantino, *ibid*, 45.

Page 48
"What we prize above all . . . "
quoted by Passantino, *ibid*, 51.

Page 68
Light falls only on his face; it is interesting to think about the composition of Delacroix's portrait of Paganini in light of "The Romantic Vignette and Thomas Bewick," in Charles Rosen and Henri Zerner, *Romanticism and Realism: The Mythology of Nineteenth-Century Art* (New York, 1984), 71–6. Rosen and Zerner remark that one of the defining characteristics of the vignette is that "The image, defined from its center rather than its edges, emerges from the paper as an apparition or a fantasy." (81). Their comment on the adoption of this type of composition for romantic paintings by artists including Delacroix and Turner can easily be applied to the little portrait of Paganini, with its

light-filled focus on the face and its indeterminate edges. Much as he loved the painting, Phillips failed to see how typical the painting was of Delacroix, at least from a formal perspective. Paganini's unhealthy appearance is set in its historical context by Nina Athanassoglou- Kallmyer in "Blemished Physiologies: Delacroix, Paganini, and the Cholera Epidemic of 1832," *Art Bulletin* (December 2001): 687–710. The romantic significance of black evening dress for men is discussed by Anne Hollander in *Seeing Through Clothes* (New York, 1978), 374–76.

Page 76
"Do not paint too much after nature . . . "
quoted by Passantino, *op. cit.*, 111.

Page 78
"The truer a work is . . . "
quoted by Passantino, *ibid*, 521.

Page 80
"Grubby, earthbound . . . "
quoted by Passantino, *ibid*, 43.

Page 82
"he could identify . . . "
Phillips, *A Collection in the Making*, 16.

Page 84
"Mine is the method . . . "
quoted by Passantino, *op. cit.*, 264.

Page 88
"line freed from delineating . . . "
quoted by Passantino, *ibid*, 271.

Page 92
Klee and The Phillips Collection,
see Passantino, *ibid*, 282–92.

Page 98
"Your portrait shocked you . . . "
quoted by Passantino, *ibid*, 297.

Page 110
The romantic theme of sad clowns is discussed by Francis Haskell in "The Sad Clown: Some Notes on a Nineteenth-Century Myth," in *Past and Present in Art and Taste: Selected Essays* (New Haven and London, 1987), 117–8.

Page 117
"the different races of the Levant . . . "
quoted by Passantino, *op. cit.*, 71.

Page 118
"Forms which will be . . . "
quoted by Passantino, *ibid*, 103.

Page 120–22
Renoir's *Luncheon of the Boating Party* is the subject of essays by Charles S. Moffett, Eliza E. Rathbone, and Elizabeth Steele in *Impressionists on the Seine: A Celebration of Renoir's "Luncheon of the Boating Party*," Washington, D.C., The Phillips Collection, exhibition catalogue, 1996. See also, Passantino, *op. cit.*, 108–109.

Page 128
"A lyric of winter . . . "
quoted by Passantino, *ibid*, 98.

Index